24/11

HISTORY OF THE WORLD IN 100 MODERN OBJECTS

HISTORY OF THE WORLD IN 100 MODERN OBJECTS

Francesca Hornak

PORTICO

History of the World in 100 Modern Objects is based on Francesca Hornak's popular column in *The Sunday Times Style Magazine*.

First published in the United Kingdom in 2015 by
Portico
1 Gower Street
London
WC1E 6HD

An imprint of Pavilion Books Company Ltd

ISBN 978-1-91023-241-5

A CIP catalogue record for this book is available from the British Library.

10 9 8 7 6 5 4 3 2 1

Reproduction by Mission Productions Ltd, Hong Kong
Printed and bound by 1010 Printing International Ltd, China

This book can be ordered direct from the publisher at www.pavilionbooks.com

For Luke and Laura

INTRODUCTION

I'm afraid I can't remember a time when I wasn't conscious of products and brands. As a small child in the 1980s I registered the nuances of Barbie versus Sindy, and was keen to be a Start-rite person, not a Clarks person. I even used to hop between Channel 4 and ITV, hunting for ads. At the time I knew I liked the little stories about people's lives and homes. But I imagine my ad-habit also gave me an early sense of our collective aspirations and anxieties. That sounds awful on paper, but it has actually brought me a great deal of fun in my work, not least writing this column for *The Sunday Times Style* magazine.

History Of The World In 100 Modern Objects all began with the Daunt Books bag. I started seeing it constantly – or at least in every Waitrose in London – as if it was the bourgeoisie's new It Bag. None of these Daunt carriers would have described themselves as label junkies, I'm sure. But there they were, clearly pleased to be a Daunt Books sort of person. The Brompton bike, KitchenAid mixer and Sophie the Giraffe were all in my sights from the outset, too, although my favourite objects were often those we use without thinking – like the plastic soy sauce fish in takeaway sushi.

As I went on I began linking different stories. There's a wedding at Thudbury Hall that spans three columns, a hipster restaurant called Pork Shop that pops up twice, and a wheelie suitcase that commutes back and forth from the house in 'Jo Malone Candle'. I wrote some columns as pairs, so that Miss Davies in 'Gemstone iPhone Cover' gets her own say in 'E-Vape', and Froufrou Dot the fashion blogger has the last laugh on Georgia Row, a bullying journalist. There are lots of incidental links too – Matt in 'Corner Sofa' is the ex who dumped Kate in 'Extra Large Wineglasses', for example, and Julian who throws the Moroccan pouffe out of his therapist's window is the angry art dealer in 'Joseph Joseph Chopping Boards'. Not surprisingly, the 'world' of the column's title turned out to be rather a small one.

Pinpointing social tribes is one of *Style*'s strengths, and I was lucky that readers seemed to enjoy seeing themselves parodied. It made the column very entertaining to write, and I'm grateful to my editors for letting me make up stories, when I was supposed to be a journalist.

CAMBRIDGE SATCHEL

Jess, 25, is angry. She's angry that her dad pays her rent, while she interns at a digital media agency. She's angry about Robin Thicke, cupcakes and Page 3. She's really angry that she had a sex dream about Spencer from *Made in Chelsea*.

Like her flatmates, Jess wears stonewash denim, buttoned-up shirts and Urban Outfitters brogues. In her Cambridge Satchel, among the detritus of Vaseline tins, flyers for new pop-ups and ironic scrunchies, is a plastic frog named Albert – found on a night out, and kept for lolz. Since all social life revolves around their old group from Sussex Uni, Jess often feels like there's nobody left to meet in the world. Maybe she'll move to New York (her answer to everything).

Jess starts a feminist blog called Patheticphallusy, and posts on dating in the age of social media. Nobody comments, except her mother, who calls from Guildford to explain that Englishmen have always been ineffectual. Jess knows this, having 'dated' the feckless Louis for months. Last night they had their first row, about her pressuring him to book a holiday. She is rather pleased – arguing means they're a real couple. Then she's angry with herself for being pleased.

HILDON MINERAL WATER

It's Rich and Claire's 10th anniversary. They park Sophia and Alfie with their nan and check into Cowton Manor, Bushey. Claire has had a blow-dry and a bikini wax. They haven't had sex since Valentine's Day.

Cowton (a stately home turned boutique hotel) is painted in Farrow & Ball Pigeon, and stuffed with oversized armchairs and old Scrabble sets. Their bed, with its army of pillows, is flanked by Hildon water bottles and multiple dimmer switches. Waffle robes and Ren products wait in the bathroom. Claire suggests they try the rainforest shower, but the torrent threatens her blow-dry, so she has to wear the clingfilmy shower cap. It's a bit of a mood killer. Rich flops in front of Sky Sports until dinner, while she tries on her new lingerie. At 7pm, they wade through the seasonal tasting menu and its many wines. After, they're too full for anything but sleep.

The bed is bliss, but Claire wakes hourly with a raging thirst. She drinks her Hildon, then Rich's, then all the still and sparkling in the minibar. At 9.49am, Rich wakes her, insisting they catch breakfast. When they check out, he is charged £14 for the minibar. She should have drunk the water from the bathroom tap, he snaps. They drive off in silence.

NESPRESSO MACHINE

Every Monday, the creatives gather round the Nespresso machine for Team Catch-Up. Today, project manager Drew kicks off with an introduction. Lauren is joining Kewtie.com from a rival fashion e-tailer. She has an awesome skill set, in terms of content deliverables. Everyone grins and cheers weakly.

Kewtie's offices are light, airy and littered with product samples. The creatives wear dungarees, and the commercial team wear fake tan. Coders go unseen. They have a wall of staff Polaroids, and cake o'clock at 4pm. On Fridays, the *Baywatch* theme signals EoP and Team Kewtie hits the pub.

Back at the Nespresso machine, Drew, 30, is suddenly unsure whether it's 'sea change' or 'step change', and ends up announcing a 'steam change'. Everyone nods. Going forward, there will be a steam change regarding their retail-editorial integration strategy across key territories. Core brand values will be delivered via a new content initiative, in terms of bi-weekly 'Call to Action' home pages. Everyone keeps nodding. A plate of croissants remains eyed but untouched.

Later, Drew emails Lauren: 'Great to have you on board!! Going forward, you'll be taking ownership of trend content from an editorial perspective.' Lauren asks for clarification. Confused, Drew replies: 'We need you to write about trends.'

DAUNT BOOKS BAG

Margaret's book club is going to an author reading at Daunt's. It was Linda's idea. Margaret, 66, would rather meet at someone's house and compare grandchildren and Arche shoes, as usual. But she dutifully puts on fuchsia tights, finds her Daunt Bag and leaves her husband a 'daal for one' ready meal, from that brilliant shop COOK.

Linda, who lives near Margaret's friend Sarah in Hampstead, has somehow infiltrated their gang. She always chooses bestsellers from the Richard & Judy Book Club. Last time they all had to read *Elizabeth Is Missing*, and felt depressed that they might be senile. Linda also showed everyone up by cooking an elaborate Ottolenghi stew. Now they all have to cook, when they used to just do nibbles.

The author at Daunt's is a young man called Andrew, best known for his first novel about an autistic cellist. Why must modern books be so gloomy? At least there's wine, though not as cold as she'd like. Linda asks a long question that is really more of a statement. Later, Margaret's husband asks why she bothers with book club, when there are plenty of classics she'd do better to re-read. Margaret can't quite remember. She just knows she likes being a Daunt Books sort of person.

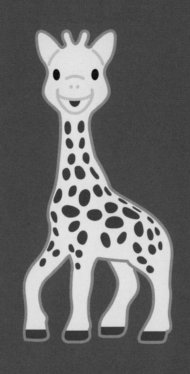

SOPHIE THE GIRAFFE

Jo met Tamsin at NCT. The group gathers weekly at Costa with their three-month-olds, marshalled by Jo's emails, titled 'Playdate and cake!' She arrives first with Archie, chubby with formula and grinning gummily from his Bugaboo throne. Tamsin, a fan of 'baby-wearing', cradles Isla-Rose in an Ergobaby papoose. The child occasionally peers out with alarmed eyes. Both infants clutch Sophie the Giraffe.

Jo follows Gina Ford, and reminds a shattered-looking Tamsin how she got Archie to sleep through at 10 weeks. 'Gina says they need to learn to settle themselves,' she says, head tilted sympathetically. Tamsin gushes that she's just 'too soft' to leave Isla to cry, after reading 'all the research' on the neurological damage it causes. She confides that she co-sleeps to aid bonding, enjoying the horror that flashes over Jo's face.

Jo agrees that 'happy mummy equals happy baby', and that since she 'really needs her sleep', they had to have routine. Tamsin fumbles for a breast to stifle Isla's frantic screams. 'The trouble is Isla's just such a livewire,' she says. 'And so sociable. She's already babbling!' Jo removes Sophie's foot from Archie's nostril. 'Yeah,' she says, beatifically. 'We're lucky this one's so chilled.'

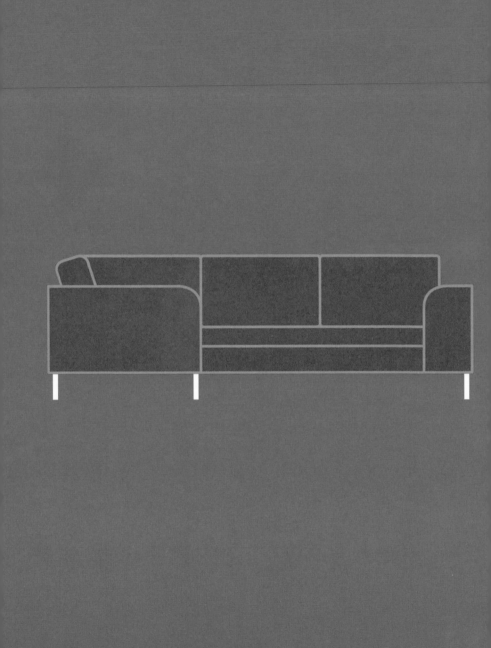

CORNER SOFA

Confronted with an expanse of white wall and grey carpet, Matt's solution was a corner sofa. And so a mammoth eight-seater came to dominate his new-build flat (two-bed, ensuite, river views, fire doors). He likes the sofa's long bit, where you can put your feet up. The only other furniture in his open plan living space is a glass table with shin-knocking metal legs.

Matt, 32, a foreign exchange trader, wears Thomas Pink at work, and the Chelsea shirt his ex-girlfriend banned at home. He drives an Audi, goes to the gym a lot and eats Tesco Ready To Eat Roast Chicken Breasts daily. When he ordered the sofa he pictured his friends coming round every weekend, shouting at sport on the 50in TV. But these days they're all busy pushing buggies, so on Sundays he lies across it alone, playing Fifa on the Xbox and drinking protein shakes.

The only other sofa action is the odd post-date fumble with hopeful twenty-somethings. Seeing them out, in the cold light of the lift, they suddenly look very young. He reassures himself that his mates would love to be in his position. But after three dates with each new girl the sofa always feels cramped, and he stops texting.

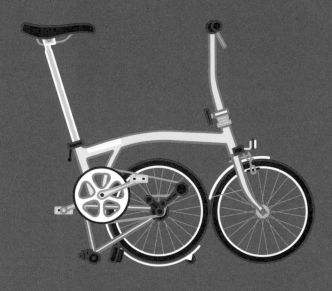

BROMPTON BIKE

Jackie, 48, is a commissioning editor at Channel 4. She recently won an award for *Beeline*, a series on urban beekeeping. Every morning she pulls on her Superdry gilet and cycles in from Kilburn, a Tupperware box of Nigel Slater leftovers in her pannier, Rufus Wainwright or Lou Reed (RIP) in her ears. The Brompton, a present from her civil partner, Emma, is the bollocks.

Jackie met Emma through Emma's ex-husband who, awkwardly, also works at Channel 4. They are constantly invited to dinner parties by couples from Emma's old life who, Jackie suspects, are delighted to show off 'our lesbian friends'. Jackie never expected to be a stepmother, or to leave her peaceful flat in Farringdon. But now she lives in a chaotic semi with Emma's children, Josh, 18, and Lily, 16. Josh complains of oestrogen overload, and refuses Jackie's barley risottos, preferring to cook everything in his George Foreman Lean Mean Grilling Machine. Lily needs nightly assistance with media studies coursework.

They're great kids, but as she cycles home, Jackie often dreams of the day they go to university. She pictures entire evenings watching *Homeland*, over pinot noir and their favourite Divine Fairtrade chocolate. She doesn't realise that neither child will move out until 2025.

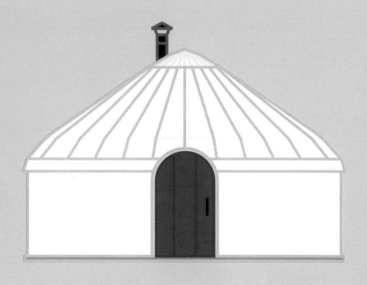

YURT

Charlie, 31, is going to meet her boyfriend Toby's friends for the first time, at a wedding in Somerset. Guests are to stay in yurts, supplied by the best man, Bento (real name Hugo Bentley), who started glamping company Yurts & Whistles. Bento's yurts are fitted with airbeds, Indian textiles and iPhone chargers. He's planning to branch into luxury treehouses.

The yurts sleep four, so Toby and Charlie are to share with another couple. Charlie is not sure how this will work. What should she wear in bed? Will she snore? Will she need to pee embarrassingly often in the night? Presumably nobody will have sex? She'd really prefer a B&B, but when she raises this with Toby, he calls her a west London princess and promises the yurt will have a socket for her hairdryer.

The wedding-party theme is Down the Rabbit Hole. Everyone seems to be wearing body paint or Temperley, and Charlie realises her Miu Miu alice band doesn't cut it. At 3am, sitting on a hay bale watching a giggly Toby take ketamine, she has an epiphany – he is not the one. At least she'll never have to sleep in a yurt again.

VILEBREQUIN TRUNKS

Chris Tabbot, 45, Tory MP and the government's first Minister for Wellness, is holidaying in Sardinia. His wife, Julia, a CEO who earns triple his salary, bought him these trunks as an incentive to diet. Apparently he is not 'on message'. When he mentioned Blair's Vilebrequin shame, she said: 'You're hardly PM, darling.' She only says 'darling' when she's belittling him.

Chris's aides have urged him to utilise Twitter. So, on the first morning of the holiday, he tweets: 'Cantaloupes by the pool #tasty,' with a photo of his hotel breakfast (Julia has banned all food except fruit before midday). He doesn't notice the bikini-clad breasts in the background. That afternoon, a party communications officer calls in a panic. His tweet has gone viral, condemned as 'everyday sexism' in Westminster. The Vilebrequins are mocked, too.

Despite furious denials and humble apologies, Chris is summoned home, leaving a mortified Julia. While packing, they row about work-life balance. He says 'melon-gate' wouldn't have happened with a croissant, and she says *The Independent* was right to call him juvenile. At the airport, he buys all the papers so he can read his story, and keeps the receipt. Definitely putting those on expenses.

DREAMCATCHER

For Christmas, Sharn, 38, is having her daughters Mhairi, Ceilidh and Thora make everyone dreamcatchers. She got the idea at a workshop at Knockengorroch, and now has the girls in a production line at her café, Rainbow Gatherings. She ignores their pleas to play the *Frozen* soundtrack while they work. Each dreamcatcher will be sent with a Snapfish photo card, showing the family's recent foraging holiday, and wishing friends a 'Happy Winter Solstice'. Special people are getting a mini homebrewed cider, and a CD of her husband Kyle's accordion troupe, Paetbog Rhythms.

Sharn's oldest friend, Lisa, rolls her eyes when the dreamcatcher arrives from Stroud. It feels like proof that she and Sharn have nothing in common any more, except their schooldays in Dartmoor. She bins the CD and foul cider, but hangs the dreamcatcher among the fairy lights in the window. 'What the fuck is that? Did Sharn send it?' asks her husband Grant, who has a keen sense for anything 'a bit Sharn and Kyle'. He smirks at the photo of their daughters, grinning in Peruvian knitwear and Gore-Tex by a VW van. 'She's a very dear friend and I won't hear a word against her,' snaps Lisa.

DUALIT TOASTER

Oscar, 14, lives in a big Victorian house in Crouch End. When he gets home from his private boys' school, he slumps on a stool in the island kitchen, WhatsApping with one hand, shoving toast into his mouth with the other. The problem is that Dualit toasters are bare loud, so his dad, Miles, a copywriter, often hears the ticking and comes down from his home office to chat. #fail

Oscar wishes they had Nutella and bagels, like at Zach's house, but his mum, Nicola, buys that wholemeal Cranks shit. It's unfair, because Oscar's the only one who eats bread now anyway. His sister, Ella, 17, genuinely eats nothing, and his parents have got into porridge. Miles went mental when Oscar said porridge was gay. 'Some of our dearest friends are gay, Oscar,' he said. 'Some of yours may be, too.' Oscar made vomiting noises and Ella screamed, because she has an actual phobia of sick. #OCD

When they get too much, Oscar retreats to his room in the loft conversion. Once, Nicola asked if he was looking at 'internet pornography' up there. He hadn't been, until she mentioned it. But mostly he's playing *Call of Duty*, or standing at the mirror pushing all his hair over to one side. #yourmum

EXTRA LARGE WINEGLASSES

Kate's extra large wineglasses live between *Jamie's 30 Minute Meals* and the Keep Calm And Carry On Shopping mugs. Kate lives in an overpriced, mouse-infested flat in Balham, with her friend Mills. On the sofa are Union Jack cushions. In the fridge there is always a bag of wilting rocket, and a bottle of Oxford Landing sauvignon blanc. Audrey Hepburn smiles down from the wall.

Things were going OK for Kate, until she hit 30. She grew up in Hampshire, made lots of friends who looked just like her at Newcastle, and got stuck into PR. But lately, life has turned sour. Every weekend, she's the token single girl at another wedding. Her boobs and blondeness don't seem to have the effect they used to. Worse, her younger, thinner sister Fizzy is engaged.

Mills puts Kate on Mysinglefriend.com, with a profile shot of her laughing in big sunglasses. She goes on dates with men in North Face gilets, and talks about travelling and how she plays netball on Tuesdays. Sometimes, after these dates, she feels she ought to cry. She achieves this by turning on Magic FM, pouring a massive glass and googling Matt, who dumped her at 28 because she was 'perfect, but it was the wrong time'.

KETTLEBELL

Lee, 32, hoped to be a professional footballer, but an injury left him with a degree in sports science and a career as a personal trainer. He works at the Grange Golf Resort and Spa, Cheshire, where his Kickass Kettlebell class is a hit with stay-at-home mums.

Lucie, a petite blonde, catches Lee's eye on the gym floor. He approaches to offer his services, and they establish that her goal is to tone her abs and glutes. By the end of their trial, as Lee stretches her out and promises a high-protein meal plan, he reckons they have chemistry. She signs up for 20 sessions. Lee starts adding kisses to his texts, rallying her to 'dig deep' and resist her 4pm sugar craving. Lucie starts training with her hair down and full make-up.

Between sets of kettlebell squats and the plank, she confides that she and her husband sleep in separate rooms. Lucie doesn't realise that Lee is equally attentive to Chantelle, a bride-to-be he sees for private boxing sessions. One afternoon, bored, with no female clients, Lee texts: 'Hiya Chantelle. Can't stop thinking about how hot you look doing burpees. Be good. L x'. Except he sends it to Lucie.

EAMES HANG IT ALL HOOKS

Eleanor and Max are both third-generation architects. They met at UCL, married and set up their practice, Lloyd-Scott-Barker. Home is a terraced house in Kentish Town, gutted to make way for rubber floors, steel staircases and banks of white cupboards. A glass extension takes up half the garden. In the hall, Eames hooks bear cycle panniers and a Parisian workman's jacket, which they share. The house is featured in *Elle Decoration*, prompting six commissions for side returns.

Since it took a decade to qualify, and another to get established, they decided to have only one child, Inigo (after Jones). Sometimes, Eleanor wonders if this was wise. What if Inigo doesn't become an architect? Who will take over Lloyd-Scott-Barker? When he is four, she takes him to a Charles Eames exhibition at the Barbican, and finds him worryingly hostile. Her fears are confirmed that evening, when Inigo drags a Thonet B32 chair to the hall, stands on it and tries to yank down the hooks shouting, 'I hate Charles Eames'. Eleanor decides Max must never know. Twenty years later, Inigo will disappoint them both by becoming a landscape gardener.

AGA

Michael and Tessa moved to their second home in Burnham Market when Michael retired, and their children, Ed and Poppy, finally left home. The Norfolk house is always too cold, so everything has to happen around the Aga, which is always too hot.

Michael, 67, didn't expect retirement to be so busy. He has become fascinated by his own family tree. Determined to unravel the mystery of Granny Gordon-Cooper's olive skin in a family of freckled blondes, he sends a saliva sample to findmygenes.com. Tessa didn't expect Michael to be around quite so much when he retired. It's wonderful that he's happy, but he's always leaning against the Aga talking about his ancestry when she's trying to cook. She buys him a little sign that says 'I'd rather be sailing', but he doesn't take the hint.

Balance is restored when Michael discovers that his great-grandmother didn't have an affair with a rajah, as he suspected, but that he has Welsh mining blood. This, say the researchers at findmygenes.com, would account for Granny's swarthier skin. Michael suddenly loses interest in his family tree, and fixes the central heating. The Aga is all Tessa's once more.

IPAD

Over Pret croissants at Stansted, Laura, 30, promises her man Olly she won't check her work email on holiday. For days she has told colleagues she can't wait to 'just do nothing', and get some winter sun in Thailand. She doesn't plan on leaving the all-inclusive resort (this declared with sheepish triumph).

To support her digital detox, Olly confiscates Laura's BlackBerry. He concedes the iPad, so she can finally read *Gone Girl*. Days later, stuck on page 97 by the pool, she's itching to check her emails. She can't stop stressing about a nightmare client. Perhaps she should peek, so she can genuinely relax. Beside her, Olly is deep in Alex Ferguson's autobiography. She tilts the screen and deftly opens her inbox.

Two hundred unread emails shimmer at her fingertips. There it is, entitled 'Merton Account – URGENT'. The client is kicking off about a perceived crisis. Laura feels sick. Why did she look? She longs to tell Olly, but instead sends a panicky response, and spends the remaining holiday furtively emailing from the ensuite. Olly, blissfully unaware, is so proud of his other half he treats her to a final dinner in town. Shame she didn't get on with *Gone Girl*.

OLIVER BONAS CAKE STAND

The cake stand belongs to Poppy, who rents a room from Fleur, whose parents bought Fleur the flat in Clapham. Both are 26, blonde, tanned and keen on turquoise jewellery. They met as interns at Kelly Hoppen, where Fleur now works. Poppy is still interning.

Poppy keeps her Oliver Bonas cake stand on the tiny table in the galley kitchen. Fleur thinks it eats valuable surface space, and puts it away pointedly every time she settles down to a rice cake. Somehow, it always reappears. Often she wakes to find a trail of Poppy's belongings, starting with grubby ballet pumps on the stairs, and ending at crumbs and a sticky knife by the toaster. Why not use a plate? Fleur rehearses little speeches about 'keeping the flat nice'. Instead she leaves the knife in situ, as 'a hint', until she cracks days later and shoves it in the dishwasher.

Finally she emails Poppy, suggesting the cake stand move, since, despite being 'so pretty' (actually its frills offend her), it serves no purpose. Poppy retaliates by heaping it with grapes and satsumas. Fleur, fuming, monitors the fruit's decay. Peace returns when Agnieska, the cleaner, smashes the offending object. But then Poppy buys a juicer.

AMERICAN APPAREL BEANIE

Sasha Wiggel, 16, can't believe he has made it through to live shows. When Louis chose him at Judges' Houses, he fell to his knees with emotion. As he keeps saying to camera: 'Things like this don't happen to people like me. Being on *X Factor* means the absolute world.'

Sasha wears his lucky neon beanie when he's filmed in rehearsal or explaining why he deserves the public vote. The trouble is, Sasha has no troubles. Life at the Italia Conti Academy of Theatre Arts has been kind. His parents, Barry and Beverley, dote on him. His nannas are still alive. All the other contestants have had, like, really hard lives. Some of them are genuinely poor and have been in gangs and shit.

But Sasha has the likeability factor. He learns to cry on cue by remembering the day his dog, MJ, briefly went missing. Blinking back tears, he keeps saying: 'I'm going to go out there and give it my all' and 'I just want to give something back to my family'. Soon, the beanie becomes an in-joke with Dermot, and gets its own fanbase and Twitter feed @sashashat. Come the finals, he is beaten by Kelly, a dinner lady from the over-25s, but reminds himself that 1D were runners-up. In 10 years' time, still wearing the beanie, he will perform at Butlins.

WEBER SMOKEY MOUNTAIN COOKER

Phil and Becky met on *Guardian* Soulmates, under the monikers manVfood and Cakegirl1980. Their first date culminated in a playful row over the 'king of meats' – pulled pork or wagyu beef – interrupted by a passionate kiss, and a surge of mutual relief, as they clung to each other outside a Chiswick gastropub.

Now they rent what Savills called a 'garden flat' (a basement, opening onto a dry lawn). Becky splashes out in John Lewis on a Weber Smokey Mountain Cooker for Phil's birthday. It works – he proposes soon after, with a sourdough baby in a Kilner jar. Despite the fact they met online, they're amazed how similar their friends are when they get everyone round for engagement drinks. The men stand at the Weber, Albam cardigans over growing paunches, discussing 'proper slow-cooked meat'. Phil uses the word 'proper' about food a lot. The women comment wryly on blokes and barbecues, and agree that men prefer girls who enjoy food.

Phil's 18-hour pork belly goes down well – nobody mentions the hint of mackerel, which he smoked for Becky in the Weber last week. Handmade scotch eggs are less successful. Phil tweets: 'Heston's scotch eggs – ridiculously runny #middleclassfoodwoes'. He's rather proud of that one. Good times.

YOGA MAT

Sophie's breakdown coincided neatly with the 2008 crash. Citibank cleared her desk, while the Priory addressed her cocaine and Manolo habit. Now 37, Sophie barely recognises that girl. She shed all her negative energy when she retrained as a yoga teacher and moved to Ibiza. There, she runs Ashtanga retreats and 'visioning' workshops to help burnt-out professionals 'unlock their inner abundance'. She meditates as obsessively as she used to monitor Bloomberg.

Since her reawakening, Sophie doesn't touch drugs or alcohol, and practises mindful vegan eating. She is nut-brown and 2st lighter than before, with an outie bellybutton, lotus tattoos and downy hair on her face. Having donated her Manolos to a women's refuge, she now pads around barefoot, wearing Buddhist prayer beads. Her mantra is: 'Don't just do something – sit there!' Friends from Roedean have noted the transatlantic accent.

One day, while waiting for a colonic cleanse, she meets Jasper, 25, a toe-ringed trust fundee. He, too, was saved by yoga, during a rough patch when he was expelled from Marlborough. They don't know it yet, but they will get together and open a guesthouse in Formentera, full of mangy rescued dogs.

JO MALONE CANDLE

Tim and Ally bought the Old Rectory, in Suffolk, to give the kids a 'real childhood'. Ally, 43, hadn't anticipated so much driving, but it's worth it to live in a rich-person-size house, instead of a hovel in Hammersmith. They've even inherited a dank pool. Tim now lives and works half the week in London, leaving Ally free to cruise Net-A-Porter in bed and open Chablis at teatime.

The Clarkes, friends from London, are coming to lunch. Ally can't forget Jools Clarke saying she'd 'die of boredom' in the country. She races around, hiding the PlayStation, trying to make a White Company throw fall naturally and swearing at Don Draper, the puppy. She lights a Jo Malone candle in the loo to hide the weird drain smell. On arrival, Jools spots the candle and says: 'You can take the girl out of W6...' Ally isn't sure if she should be insulted.

She has made 'just a salad' from the River Cottage cookbook, with chard and goat's cheese from this gorgeous farm shop (usually eschewed for the Co-op). At lunch she raves about local produce and how fab it is for the kids not to be cooped up any more. Afterwards, the adults find all their children huddled round the playroom TV, in silence, curtains drawn.

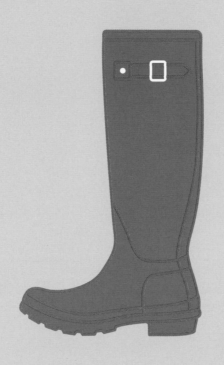

PINK HUNTER WELLIES

Aimee, 22, has just graduated in fashion communication. She's visiting her big sister, Danielle, in London, for Lovebox. Aims is well into her fashion, but it's different down here to back home in Doncaster. Dani's new friends are nice girls, but they don't take care of themselves. They'll not wear heels for a night out, and that Ellie had no make-up on.

Aimee planned her festival look weeks ago. She's wearing a white 'vintage-style' ASOS dress, like Mollie King had on in *Grazia*, a skinny belt, a Topshop fedora and pink Hunter wellies. She's had her brows retinted and a double-dip tan. Lash extensions flap on her eyes like tiny black wings.

Danielle cringed when she saw Aimee's boots. She remembered Ellie once saying that girlie Hunters were 'a bit Coleen Rooney', and that fake lashes were 'so *Geordie Shore*'. But Aimee doesn't get it – nobody from back home does.

Arriving at Lovebox, Danielle sees Ellie clock the pink boots and feels herself going the same colour. She has a tense day, half blanking her sister, half snapping at Ellie. Aimee has a great time. She loses everyone and ends up snogging the drummer in Ellie's favourite band. Get in.

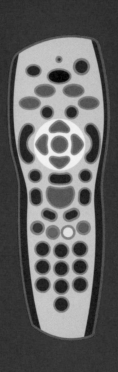

SKY REMOTE

Phillipa, 64, is having a hellish time with the zapper. Peering through her reading glasses, she jabs the Sky button, then 'OK', then others at random. She tries prodding every button, left to right. Nothing. She turns the TV off and on. There is a promising ignition noise, the light is green, but the screen is maddeningly blank. She just wants to watch *CSI* before her Duchy Originals soup gets cold.

Phillipa lives in a dim, lofty house in Bristol, her prize in the divorce. Her youngest son, Sam, recently moved out, but his stuff still jostles with her William Morris armchairs and pink lustre china. Without him, she finds she can barely operate anything – particularly the vast TV he insisted on. He has also left her with a new taste for gritty US dramas, once watched together over mint tea, now cruelly elusive. She leaves him an over-enunciated voicemail, then texts 'SOS TV BUST'.

No reply. There must be an electrical fault. She unplugs the whole system, muttering 'bastard object'. Nothing. She suddenly roars with irritation, shoving the screen, then yelping as she jars her arthritic wrist. Through her swearing she hears the door. It's a concerned neighbour. Bugger.

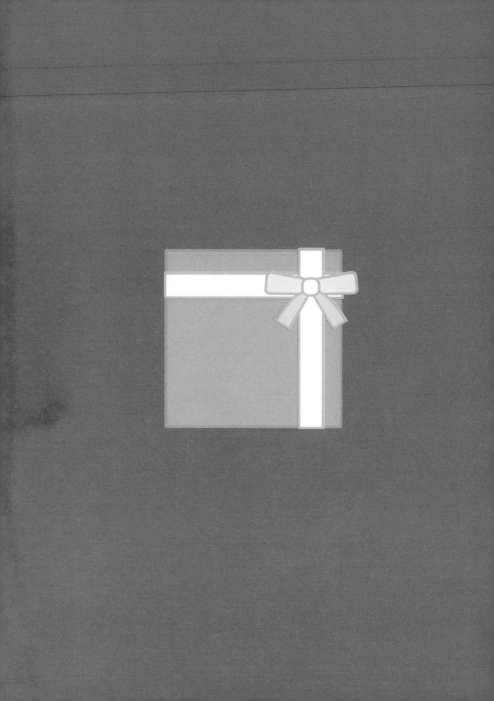

TIFFANY BOX

Nicole has been with Adam for two years. They met on JDate and now live together in Manchester. She wants a baby before she turns 30, which means, factoring in one year to book her preferred wedding venue and another to guarantee a baby, he has a month to propose. What's keeping him?

She trawls online articles entitled 'Get Any Man to Marry You', slaves over the roast chicken they advise and fights tears of impatience with each engagement announced on Facebook. In Selfridges she lingers at the Tiffany counter with Adam, pointing out stuff she likes. How can she make it clearer already? She should never have moved in with him, says her Grandma, who married at 19.

One day, putting away Adam's washing (another tip), Nicole spots a flash of turquoise among his M&S boxers. It's a Tiffany box. He must be waiting for her birthday next week. She forces herself not to peek, but texts all her friends. On her birthday, Adam takes her for dinner at Vermillion, and, sure enough, as the waiter brings her dessert with a single candle, he produces the Tiffany box. 'Happy birthday, babe,' he says. It's earrings.

WHEELIE SUITCASE

Every Sunday, Tim, a chartered surveyor, gets the train from Manningtree to Liverpool Street, leaving his wife, Ally, and kids at the Old Rectory, Suffolk. Tim, 44, works half the week in London, where he rents a bleak studio flat in London Bridge. Despite living out of a wheelie suitcase himself, other passengers' wheelie cases infuriate him. He likes to punish especially slow rollers with a sly kick. Sometimes he is rewarded with a reproachful backwards glance.

After a weekend of Ally's incessant guests and his daughters' Justin Bieber singalongs, the quiet carriage is Tim's sanctuary. He has a private ritual of a G&T and bag of Nobby's Nuts from the buffet car, while reading Robert Ludlum and texting Kim, who he has been shagging since the launch of a new office space in Docklands.

By Thursday, though, the flat always starts to get him down. He finds himself missing Ally's bountiful fridge and fragrant bathrooms, and takes to buying her peonies or Hotel Chocolat truffles in the station on his journey home. Once there, in front of the woodburning stove and *Mad Men*, they congratulate themselves again on moving to the country.

SOREL SKI BOOT

Petra Llunge-Prescott, 21, heiress to a teabag fortune, is starring in new constructed-reality show *The Slopes*, dubbed *Made in Chelsea Goes Skiing*. The series follows six chalet girls (they won't do any actual work, obvs) and six snowboarding instructors over a season at Verbier. Petra agonises over her debut outfit. She settles on Sorel boots, pink salopettes and ear muffs, hoping she looks like Cressida Bonas.

On the first day of filming, she has to pretend to be surprised to bump into her ex, old Etonian Seb, on a black run. The crew make them do the take six times. Although Petra's dream is to become an actress, it's bloody hard to keep doing her shocked face, while skiing, in the freezing cold. The producers then demand she eats fondue suggestively, and she worries her nose is dripping. Petra is thrilled when her picture appears in the tabloids soon after, universally captioned 'Bootylicious'.

It's not so great when a bitter Seb tells the press that Petra's mother was a Playboy bunny, prompting headlines about her 'trashy roots'. By series two, though, Mummy Llunge-Prescott has made several cameos and come to rather enjoy being stopped in Peter Jones by teenage girls. Seb has been written out.

RECLAIMED FACTORY LAMP

Two years ago, Justin, 42, a hedge-funder, decided he wanted to own a restaurant. He poached Rob, 36, a chef from his favourite gastropub, and now, many pints later, they are launching Pork Shop, in Spitalfields. Their interior designer, Saskia, sourced these lights from an architectural salvage yard. She's going for a factory feel, with an open stainless-steel kitchen, exposed brickwork, copper piping, metro tiles and mismatched school chairs. Food will arrive in enamel pie dishes. A vintage sausage-making machine stands in the corner. Rob is well impressed.

The menu (set to change weekly) is modern British comfort food, divided into 'sharing plates', 'hearty mains' and 'suckling pig Sundays'. Rob is particularly proud of the smoked old spot pork belly with cider glaze, and fumes when Justin declares bangers and mash would be 'more commercial'. Rob points to their website's mission statement – 'Pork Shop puts the finest seasonal, local produce centre stage' but Justin tells him to 'leave the business side to me', and goes back to discussing lampshades with Saskia.

On the opening night, Rob is sweating and swearing in the kitchen, but Justin has vanished. At 1am, Rob finds him snogging Saskia in the stockroom. Should've known not to trust a banker.

MINI MICRO SCOOTER

Anne, 70, enjoyed one year of retirement before becoming an unofficial childminder to her three-year-old grandson, Noah. With childcare being so dear, this has allowed her daughter-in-law, Chrissie, to return to work. Three mornings a week, Anne drops Noah at nursery, picks him up and entertains him all afternoon with the many garish toys Chrissie has installed in Anne's house. Much as she loves Noah, she wonders if he needs quite so much kit. But ever since she and Chrissie clashed over his name (Anne had worried he'd be teased, though, in fact, there are two other Noahs at nursery), she hasn't dared to question her.

Noah's favourite toy, this Mini Micro Scooter, is not allowed in nursery, so, after dropping him off, Anne has to carry it home. Sometimes, if the streets are empty, she likes to hop on and glide downhill. One day, zipping along the pavement, she skids and bruises her hip quite badly. When Chrissie arrives that evening and notices her limp, Anne claims to have tripped over Noah's new Trunki. It's worth the sore hip to have half the Fisher-Price in her kitchen removed by a contrite Chrissie.

CHAKRA BRACELET

This bracelet, symbolising integrity, came with an invitation to the launch of a 'revolutionary eye cream'. Georgia Row, 30, junior shopping editor at QS magazine, rammed it onto the stack of charms and cuffs on her wrist, binning the card and instagramming her trophy – careful to show some Marant sleeve.

Georgia has been a junior at QS, a dense fashion glossy, for six years. Promotions are scarce, but she can't bear to move to a less prestigious title. Every day she is 'gifted' shiny things by fawning PRs hellbent on taking her out for breakfasts and blow-dries. But at night she gets the bus home to a dark rented flat, where mould sprouts among the Chanel freebies in the shower.

Fashion week comes round – again. She reduces an intern to tears with 2am emails titled 'My tickets URGENT', using only designers' first names (Marios, Giles, Henry). At shows she perfects her 'not fussed to be second row' stare, inwardly calculating Cara's thigh gap and feeling obese. Her editor calls, demanding she interview an 'amazing new blogger', Froufrou Dot, sitting on the front row. She doesn't know Georgia was at school with Froufrou and bullied her remorselessly for her 'weird' clothes. Georgia makes the intern do it.

BONNE MAMAN JAR

Johnny, 46, known to all as Booners, has fallen for a girl who sells chutney at the Farmers' Market. She has long rust-coloured hair and wears a rather sexy little apron. On Sundays, in his Barbour and red trousers, Johnny lingers at her stall, Inner Pickle, dipping shards of cracker into tasters. He always buys at least three chutneys, sometimes pretending he has guests, and she calls him her best customer. All her jars have gingham lids, so he starts buying Bonne Maman jam and bringing her his empties. This requires much jam eating. He still doesn't know her name.

Johnny always swore he'd get out of property at 40. His plan was to get married, move back to Wiltshire and make cheese, but he still hasn't met the right girl and it never feels like a good time to give his notice.

Finding he has 40 jars of unopened chutney, Johnny invites friends round to his flat in Parsons Green for Christmas drinks. He bungs out claret, Stilton and loads of pickle and arranges the remaining jars into a pyramid, planning to regale guests with his chutney-based love story. So it's a little awkward when his friend Hugh arrives with a date – the girl from Inner Pickle.

DYSON VACUUM CLEANER

Irina the cleaner is coming. Alison, 51, rushes around, throwing her teenage sons' stuff into heaps and shouting: 'Take your piles upstairs! Tidy your rooms for Irina!' Each week her eldest, Harry, says: 'Why do you clean for the cleaner?' And each week she says: 'Because she's here to clean, not tidy.'

When Irina arrives, Alison speaks to her in a special slow, loud voice, with a slight Russian lilt (Irina is Polish). Afterwards, she stalks round the house, checking what Irina has done wrong. The spatulas are never in the right drawer, and she has to de-hotel the cushions, which Irina over-plumps and lines up behind each other. At Christmas, Alison re-gifts Irina unwanted soap, while Irina brings Lindt chocolate balls and an unintentionally kitsch card. Alison wishes she wouldn't and feels ashamed of only paying her the living wage.

Today, there is a standoff over the Dyson. Irina complains that 'Hoover, he broke.' Alison insists she need only empty the cylinder, presuming Irina is unfamiliar with the nifty 'no bag' mechanism. It's only when they dismantle the Dyson that a used condom emerges, unblocking the hose. Damn Harry. This is why you clean for the cleaner.

POLAROID CAMERA

Fashion blogger Froufrou Dot, 30, mastered her selfie pose years ago – eyes down, pigeon toes, hands grasping the 1990s lunchbox she has made her personal It bag. This was the box that held the 'weird' Korean lunches she used to be bullied for at school. Now it has appeared in *Elle*. In your face, bullies.

Froufrou lists her 'favourite things' as gingham, eggs benedict, *A Clockwork Orange*, collecting scented erasers, autumn, taxidermy and Helvetica. She was using this camera long before Instagram offered a Polaroid filter, documenting her twenties in a flattering haze. Lately, her blog has really taken off – first she was covered in ASOS magazine, then *Stylist*, and last London Fashion Week, she was front row. Soon after, a minor fake-eyelash brand invites her to be their ambassador. She accepts, after lengthy discussions with blogger friends about 'selling out', held over flat whites in Bethnal Green.

Only Froufrou's mother isn't happy for her. Why can't she have a real job? What is a 'blogger'? Where will it all end? But even she can't complain when Froufrou gets her own show on Food Network, *Kimchi Kitchen*, making fashion-themed packed lunches.

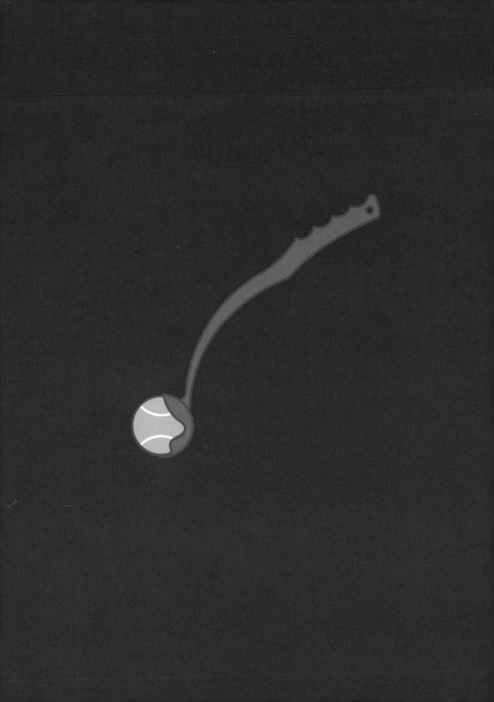

DOG BALL LAUNCHER

The dog ball launcher is one of Yvonne's favourite doggy toys. It allows her to chuck Skip's ball far enough for her to send a text, before he comes hurtling back. Yvonne, 41, never thought she'd be one of those dog mummies who buys into all the kit. She imagined, with her sensible Yorkshire upbringing, that when she got the dog she has yearned for all her adult life, it would be a big, no-nonsense hound. Then she fell for Skip, a miniature staffy, and now has a flat full of squeaky toys and poo bags in every pocket, and lets Skip snooze on her bed. She used to work so late she had no time for anything else (especially men). These days, she rushes home at six for walkies.

People without dogs don't understand. Especially mothers. Yesterday, a child in the park sneaked up behind her, grabbed the ball launcher and swung it at Skip. The poor animal started barking in terror, but the boy's mother yelled: 'Control your dog!' That really got on Yvonne's wick. She tells her sister Chrissie that night on the phone, who replies in a singsong voice: '*Sure* you don't want a baby?'

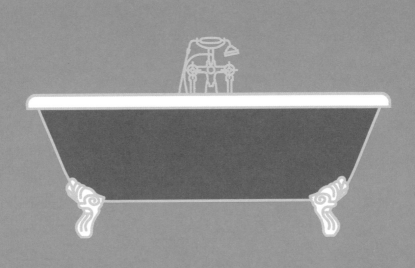

ROLL TOP BATH

'When Jools, 40, stumbled on a stunning Victorian bath at Lassco, she never expected it to kick-start a new career.' This is how Jools imagines her story will read some day in a Sunday supplement. The bath had to be shoehorned into the master bedroom, to her husband's chagrin, since the bathroom was too small. This homage to Babington House hasn't worked quite so well in Kensal Rise, with Arlo and Rafferty's non-slip mat and Peppa Pig bath crayons.

Jools returned to work in the music industry when Arlo was nine months, just as her son developed appalling eczema. She tried every cream in Wholefoods, and instructed his nursery that he mustn't eat dairy, gluten, acidic fruit or supermarket bread. She was desperate. Then a mumsnetter advised hanging organic oats in his bath. Within days, Arlo was like a different child.

Determined to help other mummies, Jools enlisted a friend in the beauty industry to develop pretty muslin poultices for eczema prone skin. The brand is called Arlo's Oaties, the logo a photo of Arlo peeping over the roll top bath. In its first year, Jools makes a profit of £12. She is still profiled in a Sunday supplement (the one her friend edits), as a 'mumtrepreneur'.

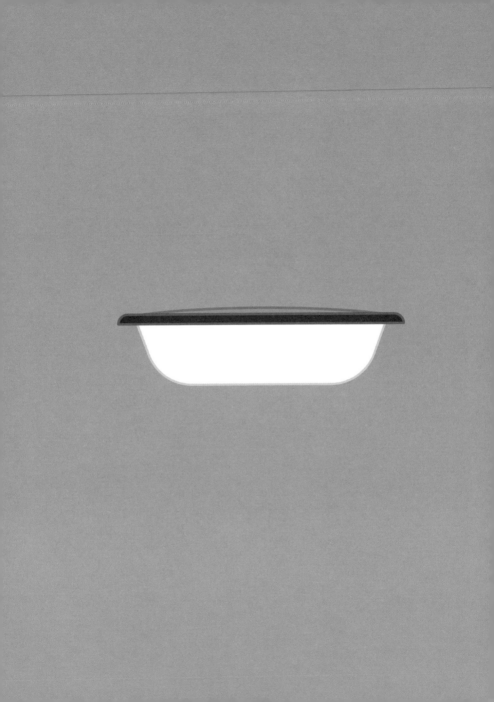

ENAMEL PIE TIN

Restaurant critic Richard Haunch, 52, is reviewing Pork Shop, a new place in Spitalfields. He is instantly irked by the industrial décor, especially the enamel pie tins that everything is served in. They remind him of camping holidays with his military father, where the only thing to eat was Heinz oxtail soup. He decides to make these grim memories the thrust of his review, confident his father will never read it. As far as Pa is concerned, all Richard does is 'fanny about with sauces'.

The food takes forever to arrive. Richard prods an artisan scotch egg, wondering if he should describe it as 'a lukewarm belch of sulphurous irrelevance' or 'a fist of gamey clag, that made H and I both shudder'. Later, he notes that Eton mess should be 'deft' and 'pert', and that Pork Shop's is neither – being peppered with popping candy 'like a lactose-intolerant unicorn's sneeze'. He's very pleased with that.

A few days after the review comes out, his father writes to say that he read it in his cardiologist's waiting room and was deeply touched, and that it had brought back many fond memories. Richard isn't sure if he's relieved or enraged.

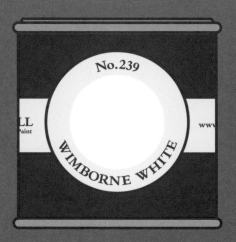

FARROW & BALL SAMPLE POT

All White or Wimborne White? Or Wevet? Or play it safe with Pointing?
Lizzie, 29, is paralysed with indecision. Each patch looks identical, but Dale
the painter has demanded a decision. He's on holiday in Turkey next week.
Must choose.

Lizzie's only previous contact with workmen has been wolf whistles. But
now, decorating her first flat, she finds herself their employer. It's not going
well. They either don't show up or arrive unannounced at 7am. They leave
dust everywhere. Ginsters wrappers and cement-crusted T-shirts litter her
lovely new rooms. She's sure this wouldn't happen if she were older, or
married. Can they tell her dad paid for the flat? Embarrassing. Must be
more assertive.

Finally, she calls Dale, requesting that he paint the hall in Wimborne
White – with real Farrow & Ball, not his preferred Johnstone's match. The
next evening, Lizzie finds it painted Strong White. She bursts into tears of
frustration, then texts: 'Hi Dale, thank you so much for the work. It seems
to be Strong White, not Wimborne. Would it be a huge pain to redo? Thank
you! x'. Dale texts back – 'Sorry Liz, brain like a siv!' – then charges for two
days' work. Should have got Polish decorators.

SIMPLE HUMAN BIN

Alan, 66, is in charge of rubbish. This being his only domestic job (apart from the odd, meticulous dishwasher load), he takes it very seriously. He raves about Simple Human's bins, with their different compartments for rubbish and recycling, and sulks if he finds an unrinsed yoghurt pot in the wrong section.

Alan and his wife Sue are going on a round-the-world trip, and putting their house in New Malden on Airbnb (their daughter Nat's idea). Alan is nervous. Not just about the trip, though he does wonder how Sue talked him into Tokyo when he should be playing golf, but about the Texan couple who have booked their house. How will they manage the rubbish? He writes them a long email titled 'trash', and then panics that Americans say 'garbage'. His fretting only confirms to Sue that she is right to drag him out of his comfort zone. He's getting old before his time, just as she's feeling like the lady in the Seven Seas advert.

The trip is a success. They return to New Malden tanned and smiley, experts in Skype, and rather soppier about each other than before. Then Alan finds a Nando's carcass in the recycling.

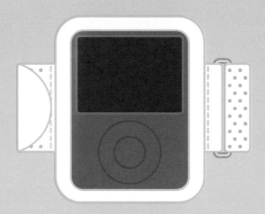

IPOD ARM CUFF

You'll find Andy, 29, in Sainsbury's after his nightly run, studying the labels on sliced turkey. He's in Asics trainers and sweat-wicking Lycra, an iPod cuff strapped to one bicep. In his basket is broccoli, Total 0% yoghurt and his treat, Meridian almond butter. Sometimes his girlfriend, Bethan, is there too. He flinches at her granola.

They're both in recruitment, working long, seated hours. She started running when she realised his training wasn't a phase (he began with a 10K run, now it's the NYC marathon). Had she not, she'd never see him. Bethan's not as lean as her boyfriend, but no less keen on Lycra. Sometimes she misses the Peroni-drinking Andy, whose Facebook page didn't chirp with personal bests.

Andy has his own secrets. His ideal body is Tom Daley's. He wishes Bethan wouldn't join his runs, but feels bad about it. He averts his eyes from her bum in leggings. His training playlist mixes Rihanna and Kylie (he says it's Arcade Fire), and his cool-down track is Beyoncé's 'Halo'. After a particularly punishing run, it brings tears to his eyes. Nobody can know that. And then there's the secret he can't even tell himself.

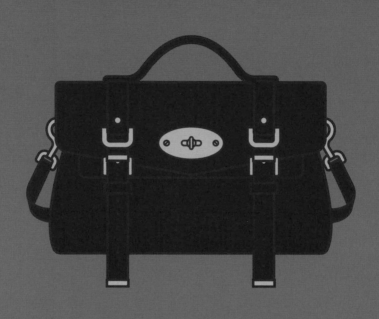

MULBERRY BAG

Rosie, 23, has been promoted to Junior Account Manager at Bassline PR. She is now trusted to take beauty journalists to The Wolseley, where she talks breathlessly about her client Arlo's Oaties, a new skincare brand. Walking down Bond Street after one such breakfast, she decides to splurge her first pay cheque on a Mulberry Alexa. Feeling invincible, she posts a selfie on Facebook captioned, 'Just went mad in Mulberry!!! Oops!!! YOLO.'

Rosie is a people person, but somehow she hasn't clicked with her line manager Nat. Hoping to please, Rosie replies all to an office-wide email, praising Nat's decision to head an Arlo's Oaties press release 'Oats Amaze'. Nat emails her privately, accusing her of taking credit for the idea. Stunned, Rosie weeps quietly in the loos. Her mum says Nat is threatened.

Worse still, at lunch, Rosie accidentally leaves with Nat's bag (she also has a new Alexa). An unopened text on Nat's phone screen reads: 'She copied your bag??? Single White Female…' Rosie shoves it away, shaking. After work, she manages to exchange her new Alexa for a Bayswater, telling everyone the next day: 'Just thought it was more timeless.' Nat starts plotting Rosie's appraisal.

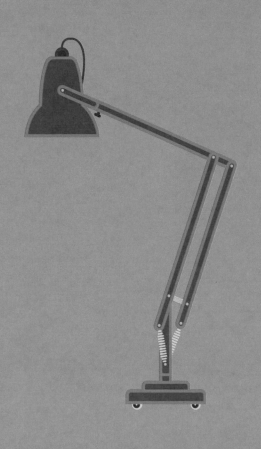

OVERSIZE ANGLEPOISE

Rising star Rollo Tate, 22, is flat-sitting for director Mike Hollingworth, currently in LA for pilot season. Rollo rather enjoys playing house in Mike's apartment, which is deep in a Hoxton school conversion and dominated by a giant Anglepoise. After drinking Mike's Scotch, he likes to recite Hamlet in its spotlight.

Rollo's break was *Moorhouse*, an ITV drama set on a psychiatric ward. But ever since his character was killed off, he has craved a part to show he's more than a pretty face. His Burberry contract pays well and keeps him on the party circuit, but he's an actor first. *Clean Up* at the Apollo, by new playwright Lottie Byle, is perfect. The cast of three has no props bar a stuffed heron. Rollo ends the play naked.

Between rehearsals, Rollo lounges in the French House, extolling the purity of theatre. His entire performance has been stripped back, rehoned. It has been deeply, deeply humbling, and an honour to work with Byle, who is just such a sweetheart. Before the opening night, he takes Mike's Bafta from the loo and practises acceptance speeches, lit by the Anglepoise. It's slightly annoying when all the reviews are about his nude scene.

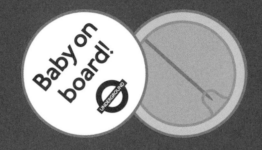

BABY ON BOARD BADGE

Tara, 36, head girl at St Paul's and now a partner at corporate law firm
Cadavar & Dew, is determined to do pregnancy on her terms. She launches
a military conception campaign with her new husband, Will, which
sees wine, coffee, tight boxers and plastic water bottles banned, and sex
scheduled around smiley-face ovulation tests. She visits an acupuncture man
recommended in the *FT* to cover all bases, and even forces her BMI over 19
for the first time since Oxford. Before long, she achieves the magic two lines
on the test stick.

At first, Tara can't see what the fuss is about. She is confident she will
breeze through pregnancy, doing her Kegels and wowing everyone by 'not
looking pregnant from behind'. But, at week six, it all unravels. Stomach
heaving, nose assaulted by her colleagues' aftershave, she starts wolfing down
jacket potatoes instead of her daily Pret salad and nodding off in meetings. By
week 14, she succumbs to a Baby on Board badge, so she can get a seat in the
crush to Moorgate. Only once she's in the lift with the managing partner does
she realise the badge is still on her Max Mara lapel. She still hasn't announced
it. Not ideal.

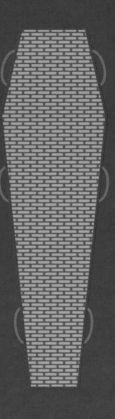

WICKER COFFIN

Jeremy, 1940–2015, is having a humanist funeral. A small gathering of friends and family surround his biodegradable wicker coffin at a natural burial ground in Oxfordshire. The celebrant, who looks a bit like Sandi Toksvig, reads 'Death Is Not The End' by Bob Dylan. As the coffin is lowered, she plays the Stones' 'You Can't Always Get What You Want' on a tinny iPod dock, prompting fond, wobbly smiles.

Jeremy, who lived on a houseboat and was known as something of a free spirit, asked that nobody wear black. His cousin Sarah can't help finding this tiresome – she would have worn her default 'funeral' coat, but instead had to buy a whole new Nehru jacket and trousers from Hampstead Bazaar. In place of flowers, he wants donations to be made to a tortoise sanctuary in Kerala.

Afterwards, the party troops to the nearest pub and agrees that the service was 'so very Jeremy', and much nicer than another gloomy cremation. Sarah nods emphatically, and says how lovely it is to see everyone in bright colours. She wishes she hadn't spent the service thinking that Jeremy's coffin looked like a giant Fortnum's hamper.

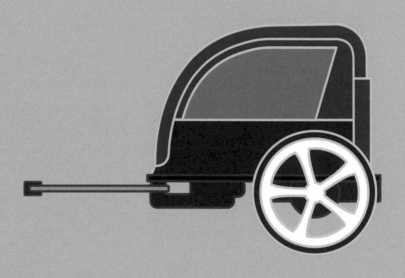

CHILD BIKE TRAILER

Every morning, Nick, 40, hitches this trailer to his Condor bike, and tows Orla and Otis to the local faith school. He and his wife, Lucy, had to start going to church to secure the children's places. Dropping them off, Nick watches pupils at the nearby prep school emerge from Range Rovers. He pedals grimly on to Glow, his 'boutique brand consultancy'.

Lucy periodically panics about the trailer's safety. Nick points out the high-visibility flag and warns of helicopter parenting. At moments like these he thinks, what's happened to me? The highlight of his day is watching *Breaking Bad*, on their sofa.com Iggy two-seater. He drinks almond milk, since the wife vetoed dairy. Weekends are spent ferrying children to classes – booked compulsively by Lucy to soothe her state-school guilt.

It wasn't meant to be this way. Studying politics at Bristol in the mid-1990s, Nick ran a drum'n'bass night called Sunday Roast. He used to MC in an improvised urban accent, and had big dreams. Now his decks gather dust in the box room that became a nursery. Sometimes, home alone, he draws the nursery blind, puts on Roni Size and bobs ecstatically by the Elmer nightlight, trying to ignore *The Gruffalo* at his feet. Hear me now!

FOXTONS MINI

Phoebe, 29, has stopped picking up her phone if there's no caller ID –
it's always Ross from Foxtons. It almost feels as if they're dating. Every
Saturday, he's there, outside another flat, floor plan in hand, flashing his
fangy, bleached smile. She wishes he wouldn't follow her into each room,
commenting on the property's 'character' and how the area is becoming
gentrified.

Afterwards, Ross never fails to offer her a lift in his Foxtons Mini. It smells
of vanilla air freshener and Davidoff Cool Water. While he raves about her
being a chain-free cash buyer, she studies his profile and imagines that his
long eyelashes come in handy negotiating a sale.

Sitting at traffic lights, Ross is always eager for her feedback on his latest
offering. Phoebe tries to come up with rational objections involving leases
and transport links, when she wants to say: 'It felt like a flat that someone
would have depression in.'

She knows Ross is getting frustrated. One day, as rain thrums on
the windscreen, he turns and shouts: 'I don't know what you want from
me, Phoebe!' It's the first time she has seen him ruffled. Suddenly, she
rather likes him.

LATEX LARP SWORD

Paul met Neil through live action role-playing (Larp) in 2002. Twice a year, they spend a whole weekend running around a wood, wearing tabards, armed with latex swords. Paul, 40, always plays a knight called Sir Gawayne of Hardon. Neil prefers to mix it up by playing a different character each time, and experiments with being an orc or goblinoid.

Paul lives in Salford and Neil in Cardiff, so they never see each other outside Larp. They've chatted over mead at the end of battles, but never deeply enough for Paul to confide that his partner, Mel, doesn't know he Larps, and that he hides his latex sword (ordered on medievalcollectibles.com) at the office. It's too late to reveal that the weekends away haven't been work conferences.

So, when they bump into each other at Welcome Break Services, on the M62, and Neil greets Paul as Sir Gawayne of Hardon, Mel is shaken. She doesn't buy Paul's story that Neil is a friend from college, and convinces herself he has been leading a double life in gay clubs. In panic, Paul confesses all and produces the latex sword to verify his story. Mel sobs that she'd rather he was gay.

ROBERTS RADIO

Claudia, 45, is a columnist, writing pithy rants for *The Times* from a cramped study in Brighton. Her ex-colleagues gave her this radio for company when she went freelance. It's permanently on Radio 4, so she has inadvertently become a fan of *The Archers*. Claudia does get dressed, but only into yoga trousers and an old, stained cardigan of her husband's. Knuckling down is a daily struggle. There is always washing to unload, or Twitter to stalk (she longs for a follow from Caitlin Moran). Sometimes she just stares out of the window eating oatcakes, for the whole of *Woman's Hour*.

For years, Claudia's special subject was 'not wanting children'. Then, to everyone's surprise, Ava arrived. Thank God she's now at school, so Claudia can procrastinate in peace. Today Claudia's column is pegged to new research on the benefits of 'interactive play' between parents and children. 'Whisper it,' she types, 'but playing with one's child is mind-crushingly boring. Frankly, mothers who find their offspring fascinating need their heads examined.'

She's rather pleased with this dig at a doting mother from Ava's school. Years later, Ava will find the column online. She'll never mention it, but will spend her twenties in therapy.

HOT TUB

Kayleigh, 23, a former Miss Liverpool and now a regular in *FHM*'s 100 Sexiest Women list, has her heart set on extending the house out the back and installing a hot tub. Her fiancé Aaron, a Championship midfielder, leaves all the house stuff to his missus, but says it sounds proper decent. Thing is, the neighbours have got a cob on. Apparently, it will ruin their view of the field. They've sent a petition with 50 signatures to the council. Against her architect's advice, Kayleigh asks them round for a drink to sort it out.

Susannah and Guy ring the ding-dong doorbell at Harping House (a Grade II listed mock Tudor mansion in Hampshire), and a very young-looking couple in matching tracksuits greet them. The man has hideous tattoos all over his neck, but the girl, thinks Guy, is charming. An hour later, she is giving Guy a spin round the village in her Bentley GT Continental Convertible, hair extensions streaming, while Aaron and Susannah sip Moët in chilly silence on the patio. Walking home, Susannah says: 'Christ. And we're going to have to look at *them* in a Jacuzzi are we?' 'I don't know,' says Guy, 'I think it sounds rather jolly.'

SOY SAUCE FISH

Dan, 32, works at Berwick Casting, Soho. Every day, after spin class, he and Tamara get lunch at Itsu. He slightly wishes she'd stop calling him her GBF. Dan likes 'unmixed-up food', so he always has a sashimi bento box. Tamara gets salad, or noodles if she's hungover. Back at their desks, Dan always gives her his little plastic soy sauce fish, because salt is ageing.

Things have been a bit tricky with Tamara since Dan met Simon. She used to be his partner in single crime. They would begin weeknights at film screenings or fringe plays, and end up dancing at the Joiners Arms, Shoreditch, or getting maudlin over Soho House martinis. The next morning, they'd buy each other Diet Cokes and snort behind their screens at Kim Kardashian links.

But these nights have been replaced by shouty dinner parties at Simon's penthouse flat with other gay couples and other permanently single women. Dan and Si have a cat, Cher, and Dan now drinks red wine. Sometimes, at these dinners, he catches Tamara staring at him as he tucks into Si's tagine and chuckles at his mister's jokes. He knows he has done something wrong, but he's not quite sure what.

BOTOX SYRINGE

Amanda Quincy, 58, doesn't look old, but she doesn't exactly look young
either. For the past 15 years, Dr Vager in Knightsbridge has been doing
her Botox. Her forehead is marble smooth, while the lower half of her face
has a spongy, muzzle-like quality. Her lips, bulbous with filler, are getting a
little lopsided.

Amanda and her husband, Scott, a Wall Street multimillionaire and
philanthropist, divide the tax year between apartments in Park Avenue,
Belgravia and Bermuda. She mostly wears coffee-coloured cashmere, and
pearls. Her hair is business-class vanilla. Life is a circuit of fundraisers and
black tie gala dinners, where men are rotund, women are gaunt and bidding
starts at five figures.

One Tuesday, reading *Vanity Fair* in Dr Vager's plush waiting room, she has
quite the shock. Vager's door opens and her son-in-law, Cameron Crawford Jr,
walks out. As they kiss on both cheeks, she notes the bloody pinpricks
around his eyes. 'Had to get a mole removed,' he smiles, teeth white as
Aspen. Amanda does not appreciate being lied to. But she can't raise her
eyebrows, so she just says, 'Happy Thanksgiving, honey.'

G-PLAN SIDEBOARD

In 2013 Polly and James moved into a flat in Clapton. They sourced a G-Plan sideboard on eBay, and put it beside their Ercol table and chairs. On it, Polly arranged a book on typography, a terrarium of succulents and some dusty Babycham coupes. Above it, she hung a Rob Ryan print reading: 'This Trumpet Will Toot When We Touch Noses In The Night'. She put a hazy photo of the tableau on her tumblr, hashtagged #grownupshelfie, and got a flurry of likes. The sideboard went on to star in Polly's brunch-time supper club PollyPutTheKelloggsOn, where she served 'nostalgic breakfast cereals' in vintage china.

Now James and Polly have a baby, Marlowe. Polly has had to ditch her Pashley bike, and her dream of opening a café offering cake and knitting classes. She no longer has time to do her daily beehive or coral lipstick. James's UKIP-voting dad tells his exhausted son that his beard is reaching 'terrorist proportions'.

One night, pacing the flat trying to jiggle Marlowe to sleep, White Noise app blaring, Polly looks at the sideboard in despair. It is covered with unsorted laundry, sticky Calpol syringes and papers for her tax return. #grownupshelfie.

MEDELA SWING BREAST PUMP

Marlowe, six months, is no fool. He knows the breast pump steals his food. He sees how the Milky One holds it to her chest, prompting the horrible mooing noise and stretching her poor nipple down the tube like an earthworm. He screams to show how strongly he disapproves, but he can't get to her because he is imprisoned in the Jumperoo.

Whenever Marlowe screams, the Milky One always starts singing 'Wind the Bobbin Up' with a wild, pleading smile. If he keeps screaming, she will start huffing and, eventually, put down the mooing pump and come over. And then, just when he thinks she's about to rescue him from the Jumperoo, she switches on its elephant sound effect and goes back to the pump.

One evening Marlowe finds himself alone on his Skip Hop playmat within reach of the pump. The bottle part is open and full of his food. He reaches for it, and it topples over, spilling the contents. The Milky One bursts in, holding a glass of wine, and swears. The Hairy One follows, brandishing a muslin, and says: 'Oops! No good crying over spilt milk.' For some reason this makes the Milky One slap the Hairy One.

TOUGH MUDDER

TOUGH MUDDER HEADBAND

Thibaud, 44, lives with his wife Alix and their twins Elodie and Margot, in South Kensington. He works for a small private equity fund where his boss, Cameron, has just hired a life coach. Cameron now sends 'Monday Motivator' emails, telling each staff member why he values them, and encouraging them to 'reach out' with any issues. Thibaud is not into this American bullshit. It's almost enough to make him relocate back to Paris, if it weren't for Hollande's taxes, and the twins' places at La Petite Ecole Française, Notting Hill.

Things come to a head when Cameron demands the team spend Sunday doing a Tough Mudder obstacle course, to foster collaboration. Despite signing a pledge: 'I understand that Tough Mudder is not a race but a challenge', Thibaud, a fanatical cyclist and amateur boxer, becomes wildly competitive. As he plunges into waist-deep water, determined to overtake his boss, he slips, slamming into Cameron's back. He staggers to the finish line, face pouring with blood, where paramedics confirm a broken nose. Alix is furieuse, and insists that Cameron pay Thibaud's rhinoplasty bill. Thibaud is just glad that the incident puts an end to Cameron's teambuilding merde.

MOONCUP

Alice, 26, defines herself as a climate-change campaigner. When her blog, Bravenewworld, was covered in *The Guardian*, she quit her day job at Greenpeace and now makes ends meet giving talks about sustainable energy (helped by an allowance from her parents). Alice has an undercut, and hoop earrings all the way up one ear. She wears sludge-coloured layers, crocheted headbands and intentionally odd socks. Her proudest moment was being arrested at an anti-fracking protest.

Recently, Alice has taken up a new campaign, encouraging women to use a Mooncup as an ecofriendly alternative to Tampax. Besides the health benefits, she aims to raise awareness of how tampons harm our planet. She dreams of giving a TED talk on this, making her a 'menstrual activist'.

The Mooncup can be cleaned in the dishwasher (Alice's one non-eco indulgence). She thinks it's hilarious when her flatmate, Tristan, picks up her Mooncup from the draining board and unknowingly tries to use it to funnel his freekeh into a BPA-free storage jar. Despite claiming to be a 'massive supporter' of Alice and her many causes, Tris doesn't seem to find it so funny.

PENGUIN MUG

Ruth, 58, has retired from teaching to Hebden Bridge, Yorkshire. Drawn by its literary heritage, she is dismayed by all the media types in Brontë country. She politely requests that they move their MacBook Airs and all-terrain buggies in the Watergate Tearooms. Despite her brisk exterior, unmarried Ruth has a weakness for romantic fiction. She reads it with Heathcliff, her tabby, on her lap and some tepid fennel tea. This Penguin *Wuthering Heights* mug was her housewarming gift to herself.

Ruth often calls Radio 4's *Feedback* and writes curt letters to newspapers. She lies in bed composing these complaints, searching for the arch note she deployed in school reports: 'Sirs, did your 'writer' really mean 'pyjama party', and not 'pyjamas party'? I presume that legs, plural, were present? Ruth Girton MA (Oxon).' Sometimes she receives hurried replies, whose grammar she relishes correcting in response.

Buoyed up by this contact, she takes a creative writing course at the local Arvon centre. Her novel will follow a teacher in 1980s Sheffield. But the tutor is more taken with a 23-year-old Irish boy who uses 'river' as a verb. When Ruth balks at this, the tutor replies: 'Real writers break rules.'

SPIRALIZER

Bea, 46, can't stand her sister-in-law, Erin, an ex-swimwear model turned reflexologist. But she can't see her brother, David, and nephews without her, so she regularly endures Erin's nasal voice and vegan cooking over long lunches. Afterwards Bea always asks her husband: 'What does David see in her?' Her husband always replies pointedly: 'She's happy. That's attractive.'

Today, Erin (who is wearing a ridiculous headband like a medieval damsel) actually brings her spiralizer to the table to give a courgetti demo. Bea's mother is doing her polite face, and saying how interesting it is. Bea says loudly that the spiralizer reminds her of the Play-Doh hairdresser she and David had as children, and she and her brother get hysterical private giggles, and she enjoys Erin looking confused.

After pudding (beet brownies), Erin corners Bea in the blond-wood kitchen. 'I'm sensing a lot of tension from you, Beatrice,' she says. Bea blushes, and protests she is fine. 'I hope so,' whispers Erin, touching her shoulder. Later, examining Erin's moisturisers in the bathroom, Bea spots a bottle of Prozac, labelled Mrs E Taylor. She knows she shouldn't be so pleased, but she can't wait to tell her husband.

MTV MUSIC AWARD

There was a time when Jake, 34, couldn't leave home without being papped. He won this award in 2001 as a member of 4some (aka Phwoarsome), who enjoyed a string of hit singles and brief celeb status. But then the band split, and Jake's acting career never took off. Now, even the invitations to switch on the Christmas lights in Hull have dried up.

The meagre royalties granted by his record company are waning, and his Chingford bachelor pad is becoming unaffordable. His mum suggests he retrain as a cab driver. When he feels low, Jake rolls a spliff and stares at the award on his Lombok drinks cabinet, under a huge black-and-white portrait of himself (taken for the *Bliss* Hot Boys calendar). He still wears the Noughties clothes he used to get for free – trilbies, thumb rings and distressed Diesel jeans with pinstripe blazers.

In Asda, Jake searches female cashiers' faces for flickers of recognition, but he can't tell if they're smiling at his blinky blue eyes, or if they know who he is. He winds down the tinted windows of his VW Beetle, making eye contact with other drivers, remembering how they used to shout, 'Oi, dickhead!' Perhaps it's time for *I'm a Celebrity...*

ARSENAL SCARF

Tom, 36, who works in digital media, has an Arsenal season ticket. On Saturdays, he makes the pilgrimage from his house in Archway to the Emirates, stopping for a venison pasty at Piebury Corner. This scarf, which he bought on deciding to support Arsenal aged 15 in Bath, is part of the ritual. Afterwards, the mood at home will be governed by the score.

Tom can't wait to introduce his three-year-old son, Henry, to the Gooners, and buys him a miniature red strip. His wife, Emily, is mortified when he takes Henry to Gymboree in it and blurts out the c-word ('common'). But Emily will never get it. She doesn't know Henry is named after Thierry, or that Tom surreptitiously checked the score while she gave birth. She wouldn't understand how the drone of the crowd stirs something primal in him. She has never seen her husband weep, but she would have if she'd come to a game.

So when his lucky scarf goes missing, Tom suspects foul play. Emily denies all knowledge, but after the row over Henry's strip, Tom doesn't trust her. Three weeks and three losses later, the scarf appears in Henry's room, under his Little White Company pillow. Go on, my son.

Day one, freshers' week, Nottingham. Charlotte, 19, is studying sociology. She has personalised her halls room with these Ikea fairy lights, hung around the crackly curtains, and her Primark duvet cover that looks like Cath Kidston. The girl next door has the same one. Charlotte struggles to leave the room. She keeps spritzing more Tigi Bed Head spray, and rechecking all the Nottingham Freshers Facebook groups.

In the neon-lit shared kitchen, she has an awkward chat with a boy called Gareth, who has terrible skin. He is unpacking an entire Sainsbury's Basics crockery set, and tells her he is studying chemistry and makes an 'awesome stir-fry'.

In the bar, third-year rugby players are already downing 'red beer' (pints of lager, Strongbow and Ribena). They look about 30, with no necks, signet rings and booming voices. After goading Gareth to do shots, they christen him 'Welsh Gareth', and he looks pathetically grateful.

By the end of the week, Charlotte has dressed up as a nympho nurse, a gangsta's ho and a squirrel (in her onesie). She never speaks to Gareth again, but he will think of 'Fit Charlotte' every time he sees the fairy lights glowing in her window. If only he'd taken his chance in the kitchen.

SQUEEZY MARMITE

Squeezy Marmite has become a bone of contention at Château l'Avare, a B&B run by expats Robert and Fiona. Since moving to Provence in 2001, Robert has gone to great lengths to import Marmite, along with PG Tips and Gordon's Gin for his signature G&Ts. He and Fi pride themselves on creating 'a home from home'.

Nostalgia aside, Robert initially thought Squeezy Marmite more hygienic than the old glass jar. The drawback is that it encourages more liberal use – a sticking point at €10 per pot. Robert ponders this in bed, unaware that Fiona is also awake, rewording the welcome pack in her head with new detail on the honesty bar, the pool filter, what can and can't be flushed down the loo and a million other things Robert is oblivious to.

One Saturday, after a toddler squirts a whole pot of Marmite into the pool, Robert adds Squeezy Marmite to the extras on the family's bill. That evening Fiona summons him to the chateau's creaky PC. The child's mother has posted a scathing review on TripAdvisor, recounting the Marmite episode. Fiona takes Tilly the dog for a long walk in Cézanne's hills, wondering if the French courts would agree this is grounds for divorce.

MANKINI

When Mark saw the mankini in his best man Olly's suitcase he was like, 'Shut up.' But after six pints his stags push him into it with only a token protest. He leads a conga to Es Paradis, San Antonio, and it's there that he bumps into Gemma, his ex.

Gem was the girl he always thought he'd marry, not his fiancée Hannah, who is back home going mental over wedmin. Hannah's the one, of course, but he went out with Gem for seven years if you count all the breaks. He was gutted when she ended it.

Gemma knew Mark was engaged, but it's still weird to see him on his stag. Although he looks a total knob in a mankini and loafers, he's clearly been working out. He smells the same, when they hug hello.

The stags do Jägerbombs, and things get messy. When a house remix of Ed Sheeran's 'Thinking Out Loud' comes on, Mark grabs Olly and does all the dips and lifts he and Hannah are learning for their first dance, but really fast. In a pissed blur, he hopes Gem is watching, and seeing how he's moved on. She is watching. And the sight of Mark lurching around in a neon thong reassures her she made the right call.

BUNTING

Hannah, 30, works in HR, although for the past year every working day has been spent planning her wedding. The theme is English tea party, and the venue is Thudbury Hall, in Dorset, even though she's from Hertfordshire.

There will be peonies in mason jars customised with lace, initialled cupcakes on mismatched cake stands, cocktails in teacups (like that bar where they had the office party), favours that say 'Drink Me' and moustaches on sticks. The table plan will be written on yellowing 1920s postcards, pegged in a tree, and Hannah will source a vintage typewriter for guests to write the couple messages.

Above all, she must have bunting. So she and her hens sit sewing 500 gingham triangles onto ribbon, while her GTB (groom-to-be), Mark, is on his stag in Ibiza. Mark has given up on opinions, until his mother objects to gin in teacups. The couple row about her meddling, and Hannah says darkly that it's 'a sign'. They settle on tealights in teacups.

On the day, it rains, her brother bungles the Pooh Bear reading and the typewriter breaks, but everyone admires the bride's unique styling. She captions her Instagram pictures: 'Best day of my life.'

EMMA BRIDGEWATER BUTTER DISH

Foff, a large, black tom cat, lives in the Tudor wing of Thudbury Hall
with Lord Drayton, 80, and Mrs Wallace, the housekeeper. Lord Drayton's
daughter, Isabella, lives with her husband and sons in the new Salvin wing
(built 1850). Foff mostly hangs around the back kitchen and the electric
fire in the morning room, now that nobody bothers with the real fires. Lord
Drayton is terribly fond of Foff. He even lets him bury his face in the Emma
Bridgewater butter dish – Foff's favourite thing.

Isabella is not so keen on Foff, and always says in his earshot that she's
a dog person. She recently got Thudbury set up as a wedding venue, since
Papa can't afford to fix the roof and won't sell the Van Dyck. One humid
Saturday, Foff slinks into the marquee before the guests, and methodically
licks the butter pats on each table. The catering manager makes a huge fuss,
and says Thudbury is 'a health and safety nightmare'. Isabella says it wouldn't
have happened if Papa didn't encourage Foff to nuzzle the butter dish. Lord
Drayton suddenly bellows that he never wanted these ghastly people in the
house anyway. Isabella wonders if ITV are filming any new period dramas.

BUBBLE GUN

Cowboy Bubble (real name Colin), 43, has been a children's party entertainer for 10 years. Originally, entertaining was a just sideline to singing, but now he's a minor celebrity across north London he can extort £150 per hour from desperate parents. Often he is invited to meet the birthday boy or girl in advance, to discuss their wishes. It's criminal how the little bastards are indulged, he thinks. On weekdays, Colin hosts Bubble Babies in a town hall, attended by ashen new mothers and posseting infants. He despises them, too.

Colin's trademark is whipping the bubble gun out of a holster and firing shots at the kids, shouting: 'Hands Up! Here come my bubble bullets!' The little brats love it. So he's livid when Tanya Green, a mother at one of his most lucrative prep schools, sends a petition round her son's class requesting he call his bubble gun a 'bubble hairdryer'. Apparently, the gun references may incite aggression. Colin protests, but is warned that Tanya, as form representative, is never disobeyed. Still he refuses. It's galling that when he next fires his bubble gun, in Tanya's presence, a child lunges forward and bites him on the groin.

ARMAND DE BRIGNAC
ACE OF SPADES MAGNUM

Alexander is celebrating his 25th at Mirage, a Mayfair club where tables are £1,000 minimum spend. He's with his cousin Anton and best friend from Harrow, Nikos. Alex orders a £1,600 magnum of Armand de Brignac Ace of Spades champagne, unaware that Anton and Nikos have already put three on his tab. The bottles arrive, fizzing with sparklers, too late to send back. Besides, Alex can't lose face with Mia, his favourite hostess. She isn't like the girls who flock to his table. She's only hostessing to fund her journalism MA.

Nobody knows Alex is drinking to numb a recent row with his father, Dmitri, who demanded he show some interest in the family firm and stop frittering away his millions 'on Greek Goose vodka'. Alex replied that, since his dad doesn't trust him, there's never anything he can do anyway.

The magnums keep coming, and with them more girls. At 3am, a slurring Alex finds Mia on his lap, admiring his new Hublot, while he rants about his dad. That weekend, a story appears in the papers headlined 'Oligarch's son's £20,000 bar tab', on second-generation BRIC wealth. 'A hostess' is quoted beside a photo of Alex's Mirage bill. Alex takes the private jet to St Barts.

BUGABOO BEE

Ana, 24, is nanny to Leo, 13 months. Every day his mother Harriet, 34, leaves the two of them with organic purées, and an itinerary of local baby activities. Ana nods and smiles, catching only half of what Harriet says. She doesn't know how her fragrance lingers on Leo's scalp, maddening his mother at bedtime. Harriet doesn't know that everyone is sick of hearing about her feelings towards her nanny.

One Friday, Harriet gets out of work early and rushes home, anxious to see Leo. Walking past her local library, she is shocked to see her son's Bugaboo parked outside, recognisable by his Heimess mobile and a distinctive Ella's Kitchen purée stain. He is meant to be at Bubble Babies music until four, not here. Why has Ana disobeyed her? Is she lying to her every day? Besides, it will be Story Time at the library, which is too advanced for Leo.

Feeling panicky, Harriet calls Jo, an NCT friend, asking if she should walk in and confront Ana or wait to see if she lies. Jo gives her standard answer, which is that childcare is all about 'finding a balance.' Later, Jo recounts Harriet's dilemma on a Mumsnet thread headed First World Mummy Problems. LOL.

BANANA GUARD

Every morning, Ian's wife, Helen, packs him a ham sandwich and a banana in this special protective case. Ian, 40, commutes from their semi in Raynes Park to the IT helpdesk at X-Tox Media. He wears static shirts, bought by Helen, except on Fridays, when he wears a maroon T-shirt that reads, '404 Error: Beer Not Found'. The X-Tox staff often yell abuse at Ian down the phone, but it's OK. Computers, and the comics he collects, are all he really understands.

Nobody would suspect that Ian was having an affair with Cat, the only woman on tech support. It started months ago, when she was upset by some cow in accounts telling her she was an 'incompetent geek'. Now they meet for lunch in secret most days. Ian takes forensic care to cover their email trails.

One day, though, Helen finds a note tucked in the banana guard. It reads: 'Banana Man, Cat Woman wants 2 lick u l8er ;-)'. Ian desperately tries to blame the lads at work, but Helen's not buying it. She hurls the banana guard at her husband, hitting him hard on the temple, and walks out. Ian wonders if Cat makes good sandwiches.

DIAMANTE DOG COLLAR

Meegan Sky, 20 (real name Megan Beaver), just landed in London, England, to promote her new movie, *Groom Service*. Her agent promises this role, as the heroine's hilarious BFF, will catapult her from Disney Channel to A list. Raised in Illinois, Meegan's big break was a Twinkie commercial, aged six, which saw her family relocate to LA. She still credits her parents (now divorced after bitter rows about her earnings) with keeping her grounded #soblessed.

Meegan is crazy in love with Tutu, her pug. Right now he's magenta, after she had him dyed pink at a pet spa. So cute! Plus it's, like, a totally natural, beet-juice-based tint. She 'kept' his $500 diamanté collar from a *Teen Vogue* photoshoot. Her therapist says she has kleptomaniac tendencies (whatever), and prescribes Xanax. Sometimes she imagines swallowing the whole bottle, and the ensuing headlines.

Meegan nails her first interview. Stockinged feet tucked under bony buttocks, she patters away about yoga, privacy, eating 'like a horse', being 'a total dork' and putting Tutu on a doggy detox. But the second journalist mentions those shoplifting rumours. Panic grips her chest. The dog saves her by vomiting kale down the reporter's leg. It's all good – Tutu's body is cleansing itself.

JOSEPH JOSEPH INDEX CHOPPING BOARDS

Julian, 50, an art dealer, has dumped Terence, 40, a picture framer, after two years. The catalyst was Terence's Valentine's card, which read: 'Loving you was the best decision I ever made.' Terence couldn't see the problem. Julian replied that his not understanding was the problem. Now Terence must remove his stuff from Julian's Marylebone flat. Their Joseph Joseph chopping boards, bought together in the honeymoon phase, have caused a row. Julian says they should stay with him, as the more fastidious cook. Terence says it's only fair they keep two each. Julian does the snorty laugh that now makes Terence wince.

Finally, Julian storms out and buys a new set of boards at Divertimenti. When he gets back, Terence has vanished, so he bags up Terence's stuff and leaves it outside with the new boards and a note that says: 'Dumping you was the best decision I ever made.' He puts on Rossini very loudly and hammers a filet mignon. Terence arrives soon after, with the new set of boards he bought for Julian at John Lewis. After knocking for ages, he leaves, with a bin bag full of grooming products, tears in his eyes and eight chopping boards.

SELFIE STICK

Lydia is furious with her ex-husband, Robin, when their daughter Molly, 11, returns from a weekend at his house with a selfie stick. She thought they had talked about fostering positive body image, and now he's practically teaching her to pout and pose and God knows what else. After two days home alone, which should be luxurious but was just lonely, she is ready for a fight.

Molly loves the selfie stick – a present from Daddy's girlfriend Freja. Molly didn't like Freja at first, especially the way she always tickles Daddy, but now she thinks maybe she's OK. Freja is just happy that her gift was a success. After months of monosyllabic replies, Robin's daughter seems to be thawing.

Robin gets a call from his ex-wife, giving him hell about the selfie stick. Isn't it enough that he pays thousands in child maintenance, without her controlling the precious time he has with Molly? He knows better than to tell her the selfie stick was from Freja. So he says gently, 'Actually, Lydia, Moll asked for it so that she can take photos of you guys together, now it's just the two of you.' He knew that would shut her up.

THERMO COFFEE MUG

Sam, 33, is militant about getting a seat on the 7.51am from Hitchin to Kings Cross. To achieve this, she must powerwalk to Platform 1 in her Saucony trainers and pencil skirt, decanted homebrewed coffee in hand. If she's lucky, she gets a seat near the hot guy who wears pink shirts. The thermo mug was a Secret Santa from her colleague Kerry, also a legal secretary, who knows Sam loves her coffees. She now saves £61 a month on Starbucks. Result.

Sam always reads *Metro* in this order – murders, celebs, stars and finally *Rush Hour Crush*, where readers message strangers who've caught their eye. Once, on a Friday night in Browns, Kerry made her text in: 'Pink shirt, we make eye contact on the 7.51 from Hitchin. Coffee? Curvy Brunette.' It wasn't printed, but got her thinking she should put herself out there, so she joins Tinder.

One morning Sam reads: 'Foxy lady on the 7.51. You were enjoying your coffee. I was enjoying you.' Convinced it's for her from Pink Shirt, she holds his gaze and smiles. It's actually from an obese divorcee to a student in Coach C – but when Pink Shirt realises he's in there, he likes Sam on Tinder. Result.

POWER DRILL

Martin, 67, gets an email from his daughter Amy, 32. 'Hi Dad, just got some vintage mirrors... Could you come and hang them, pretty please? xxxx' Although Martin is retired, Amy's constant DIY needs have become a full-time job. Her husband, Jesse, hasn't the foggiest about anything practical. He doesn't even own a toolkit, so Martin keeps his favourite drill at their flat in Tooting Bec (which he paid for).

A pile of 1930s mirrors with curvy edges, spotty glass and rusty chains awaits him. Amy wants them hung together in a 'cluster', and has left a page of *Living Etc* for him to follow. Not to Martin's taste, but he never questions Amy. Jesse, who works 'flexi-time', wanders past in a dressing gown. He looks a little alarmed at the drill, and offers Martin a Nespresso. Typically flash. Martin explains, in detail, how one mirror has proved too heavy to hang today, as it needs an extra-large screw, knowing Jesse isn't listening.

Back at home in Kingston, Martin rants to his wife, Gill, about today's young men. But, the next day, he finds Jesse using his drill to hang the mirror, having got a bigger screw. He should be pleased, so why does he feel put out?

SONIC MOUSE DETERRENT

Kirsty, 37, a food scientist and expert in sausage density, has lots of little systems. She flushes the loo with her right foot, opens doors with her elbows, and punches in her Pin with one knuckle. She is never without hand sanitiser.

Kirsty lives alone in an immaculate flat in Cambridge. One night, she is woken by a scratchy, clicking noise, like clipping toenails. It keeps stopping, just long enough for her to wonder if she is imagining it, and then starting again. Suddenly it seems to be right under her bed. She turns on the light and lets out a bloodcurdling scream as a mouse shoots across the floor. She spends the rest of the night rigid with fear and disgust.

The next day, Kirsty spends seven hours Dettol-ing her flat. Her home feels tainted. She is afraid to put down poison in case she accidentally ingests some, but is too squeamish for traps. Instead, she invests in a gadget which emits a sound that repels rodents. That night, she hears the same scratch, scratch, scratch. On goes the light. A mouse is lounging on the machine, chewing a hunk of wastepaper basket. Is it Kirsty's imagination, or is it laughing at her?

GEMSTONE IPHONE COVER

Chloe, 15, hates Miss Davies. She thinks, because she's, like, young for a teacher, she can be their friend. But she's so freaking patronising. Last week, she separated Chloe and Holly for no reason. Well, tbf, they were changing Chloe's Twitter profile (to 'Just another typical fangirl. Love 1D, Lawson, Room94. Be yourself ur unique'), but Miss Davies went mental. When she gets angry, her nostrils flare out. Holly does an amazing impression of her, LOL.

Chloe is in year 11 at a new academy school in Southampton. She is genuinely addicted to her phone. This pink gemstone cover brings her good luck – the day she bought it she got a follow from @LawsonRyan *screams*. Now she's wishing for an inset day on a Tuesday, so they can miss double Miss Davies.

One Tuesday afternoon, Chloe starts tweeting, 'Listenin 2 Kiss You still makes my heart literally melt,' when Miss Davies sees her and loses it. She snatches the phone, reads the screen and does this evil smile. 'I'll be returning this to your parents tonight,' she says. OMFG. Chloe isn't fussed about parents' evening, but four hours with no phone will be like actual torture.

E-VAPE

Teaching has been a massive challenge for Jen Davies, 27. People just see the long holidays, not the lesson planning and Ofsted reports and curriculum reforms (cheers for that, Michael Gove). And she still struggles with discipline. After school, holding court at the pub, she likes describing her teenage pupils as 'feral'. But the stress is getting to her. She was smoking 20 a day, so the GP recommended e-cigarettes, along with her SSRIs. Now, an e-vape sits charging by her bed every night. She calls it 'the gift that keeps on giving'.

It's parents' evening. Jen is primed to tell Chloe Hertford's parents some home truths about their 'gifted and talented' child (little cow). She takes a deep breath and explains, politely but assertively, that their daughter must apply herself. To prove her point, she hands over Chloe's iPhone, which she confiscated earlier. But Mr Hertford replies: 'Miss David, with all due respect, surely it's your job to motivate Chloe to apply herself? And she has a phone for her personal safety – as parents, we would appreciate it if you respected that.' He looks pointedly at the e-vape sticking out of her bag. Jen suddenly feels 15 herself.

Charlie Bigham's

CHICKEN KORMA
& PILAU RICE

CHARLIE BIGHAM'S MEAL

Funnily enough, Caroline and Antony met once, long before they married, as students at a New Year's Eve party, 1964. Antony thought Caroline was a knockout, but was too shy to approach her. So she married smoothie Nigel, and Antony married the ghastly Virginia, and it was only when they both emerged from their divorces and met again at a dinner party that they got together.

Marriage second time round, without children and work, is very different. At Caroline's godson's wedding, they are the only oldies to really dance. They still like to kiss on windy walks. They call each other Pooh and Piglet, and get the giggles in Waitrose. She can't remember Nigel ever coming to Waitrose.

Their guilty pleasure is a Charlie Bigham's ready meal. Well, they're not ready meals, really; some of the chicken ones you have to sort of cook. But when Caroline thinks of the years she wasted chopping, stirring and seasoning for Nigel – only for him to go off with her friend's daughter – she knows she has it right this time. Although if she hadn't found Antony, Charlie Bigham looks pretty dishy. Ho-ho.

EAMES LOUNGE CHAIR

Will is interviewing Alexia for Creative in Residence at Upstart Capital. From its website, Alexia knows Upstart is a 'seed-stage investment fund specialising in tech start-ups'. They are sitting in the meeting area, in Eames lounge chairs. Will, an Upstart co-founder and friend of her brother's, keeps leaning back and spinning in his chair. He asks Alexia, 27, why she quit advertising. She says the agency was too corporate, and he looks impressed. Her real gripe was the Windolene account.

Once hot-desking at Upstart, Alexia realises nobody seems to know what Creative in Residence entails. Whenever Will stops by her laptop she mentions transforming the Eames chairs into an 'inspiration hub' with neon light signs. But mostly she reads *Mail Online* and eats muesli out of a Sports Direct mega-mug.

Six months on, they are back in the chairs. Will leans forward, looking pained. Upstart is downsizing, so they have to let her go. He keeps saying, 'It's so shit, I'm so sorry,' and rubbing his beard as if he wants to pull it off. Alexia knows she should be angry, but walking into the Clerkenwell sunshine, she just feels high with relief.

GRAHAM & GREEN POUFFE

Jayne, 55, retrained as a psychotherapist after her second divorce. She works from home, seeing clients in an overheated loft conversion. This, she says, is their 'safe space'. A Moroccan-style pouffe, bought after a cookery course in Marrakech, sits at her feet. Jayne often has clients talk to it, imagining it is the person, or thing, that troubles them. It regularly stands in for ex-lovers, mothers-in-law and tricky siblings. Once, it played a much-regretted PIP breast implant.

Jayne's website says she offers 'an integrative therapeutic approach, utilising elements of CBT and relational therapy to identify problematic behaviour patterns'. She doesn't realise she has a rather off-putting habit of glancing at the clock on the windowsill while her clients talk. Or that she now treats friends and family to the same leading questions and 'accepting' tone she mastered on her MSc in psychodynamic counselling.

One day, having played an emotionally unavailable father, the pouffe is flung out of the window by Julian, who is seeing Jayne for anger management. 'How did that feel, Julian?' she asks, checking the time and trying to remember which client is next. Julian rears up again and hurls the clock out after it.

APPLE WATCH

Katy, 26, is going on a blind date with Louis, arranged by mutual friend Alexia. They are meeting at a pop-up in Dalston. Louis, an aspiring documentary maker, is late (he lives nearby, but can't get his top knot right). Katy sits nursing an Aperol Spritz in a jam jar, and trying to check her eyeliner flicks in her phone.

Louis arrives, noisily. He looks like Jamie Campbell Bower, which is not her thing, plus she hates top knots. She starts imagining him buying hairbands, and realises she has no idea what he's talking about. He is demonstrating his new Apple Watch, tucked between Burning Man wristbands. She jokes about his lax punctuality, but he has moved on to the app he hopes to create. It's called Fry-App, and will locate your nearest English breakfast. Having established that she works in native advertising, he asks no further questions.

Just as Louis is recounting a pub quiz victory, his Apple Watch pings with a reminder to move and he starts doing comedy star jumps. Katy takes this as her cue to summon an Uber. The next day, Alexia tells her that Louis said she was 'a sweet girl.' Soon after, she hears that Louis and Alexia are going out.

CROCS

Carol is having trouble with her daughter Abigail, 14. She has started refusing the clothes Carol buys her, even a jazzy pair of red Crocs. When Carol points out that the rest of the family, even Dad, all wear Crocs, Abigail says in a new sarcastic voice: 'My point exactly'. She used to love manning the tea and biscuit table after church, and accompanying Carol's Sunday School worship group on her sax. Now she's always up in her room watching *Game of Thrones*. She looks different too. She has dyed her hair black, though it's come out more purple, and started wearing nasty cheap chokers and plum lipstick. Yesterday she blanked Carol on the High Street. Carol's husband Peter says it's just a phase.

The final straw comes when Abigail thumps downstairs demanding a lift to the station, wearing a black T-shirt that says: 'I'm a lot sexier on the internet.' Peter tells Abigail that the top is inappropriate at her age. She replies that Peter's yellow Crocs are inappropriate at *his* age. Carol loses her temper and says Abigail is behaving like a little tart. Just as well her daughter doesn't know that Carol is self-publishing an erotic eBook.

JEAN PAUL GAULTIER FRAGRANCE BOTTLE

Daisy, 31, is having a Proustian moment in World of Duty Free, Heathrow Terminal 4. Her new husband, Joe, is off buying a Robert Harris for their honeymoon in Mauritius. Gripping a familiar hourglass bottle, she inhales the talcy scent of Jean Paul Gaultier, the fragrance she wore throughout university. Instantly she is back in The Cave nightclub. She is drunk and beautiful, 50 Cent is playing, and when she dances, she knows people are watching.

A moment of eye contact at the bar may lead to a Red Bull-laced kiss in a sweaty corner. Numbers will be swapped, another drama set in motion. She suddenly remembers a rower she dated in her third year, with a rippling stomach and sweetly surprised eyes, and the cabbagey scent of Eau D'Issey in his student bedroom.

Her reverie is interrupted by Joe. He is wearing glasses (will he ever wear contacts again now they're married?) and his holiday shirt. 'Did you pack the Imodium, Mrs?' he asks, before spotting the bottle in her hand. 'Ah, I know what you're up to. It's your 'new phase, new perfume' thing, right? Go on then, I'll get that.'

NIPPLE TASSEL

Every Tuesday, Karen, 43, goes to Minxy Burlesque in Sevenoaks. There, above a gastropub, 12 lovely ladies learn the 'art of tease' with Madame Minxe. Sometimes they have a sneaky vino after class. Karen booked the course after her latest self-help tome, *Conquer Comfort Eating and Find Love*, advised a hobby that celebrated her curves. Now, channelling her alter ego, Kitty de la Fontaine, she feels different. She feels empowered.

Her nipple tassels arrive from Amazon 10 minutes before she has to leave for work. She slaps them on, slightly lopsided, slips into her towelling robe and treats Steve, her cat, to a 'Big Spender' striptease in her sandstone bathroom. The tassels prove a nightmare to peel off. She has to leave with one stuck fast, and one sore nipple.

Karen is PA to Steven, an accountant. She prides herself on remembering his favourite M&S biscuits, and has taken to practising her 'saucy strut' around the office. Today, back from a Costa run, she notices him staring at her chest, and suddenly remembers the tassel. Does it show through her Next blouse? The old Karen would have blushed, but she thinks, 'What would Kitty do?' and gives him the cheeky sidelong look they learnt in class. Empowered.

UKULELE

Novelist Andrew Burke, 42, bought his ukulele on a whim, the day the divorce came through. He imagined jolly Mumford & Sons singalongs with his children, Matilda and Arthur, but when they stay, they only want to watch Netflix and quarrel. Undeterred, he buys an embroidered Navajo strap, so he can wear the ukulele on his back at Hay-on-Wye literary festival. The rest of his festival look is deliberately crumpled seersucker blazer, yellow chinos and straw trilby (to hide his thinning patch).

Andrew is working on his third novel, a young-adult book about a boy who wakes up as a dog. After his first novel, at 30, Andrew was profiled as a 'voice to watch'. But then came children, his second book flopped and he had an affair. Now he teaches creative writing and is toying with a ukulele-based stand-up routine. At Hay, he goes to lots of smug talks (during which he daydreams that he's the speaker) and flirts with a pretty, frizzy-haired events organiser. He promises to serenade her later, on his uke. While queuing for an organic ice cream, he sees a little girl in a Boden mac like Matilda's and his heart jumps – but it isn't her.

VITAMIX BLENDER

Rachael, 29, is doing the 5:2 diet using the Vitamix, a Christmas present from her fiancé, Ben. On fast days she blends a kale, lime and avocado smoothie, which, she tells colleagues, keeps her full until 3pm, when she savours a rubbery hard-boiled egg. After work, the Vitamix produces a watery tomato soup that invariably gives her heartburn.

Ben is on the 5:2 too, so they can both lose weight for the wedding. But Ben, bless him, is clueless. He thinks a Pret Love Bar is 'healthy' because of the seeds. He'll happily wolf down full-fat hummus. On his fast days, he pollutes the blender with a protein shake, refusing Rachael's green juice, and survives the rest of the day on cottage cheese. No vegetables. He starts talking about how great he feels. Rachael collapses sobbing on the kitchen floor, having switched on a soup-filled blender without securing the lid.

A month later, she is furious. Not only has she gained 5lb (can't you eat what you want on non-fast days – including cake?), Ben has lost a stone. He tells her it's the protein shakes. Rachael resolves to cut out sugar.

MYWAITROSE CARD

Every morning Declan and Charles nod at each other in Little Waitrose, as they collect a free coffee with their myWaitrose cards. Declan, a 55-year-old social worker, is a part-time performance poet. He discovered the genre on YouTube and now recites his stuff at poetry slams in a special emphatic voice, unconsciously inspired by Benjamin Zephaniah. When he can, he takes his latte to his favourite park bench and sits reciting his lyrics just loudly enough for passers-by to hear.

Charles, 74, a retired civil servant, knows he could get a better cappuccino elsewhere, but refuses to be fleeced of £2.70 for a hot drink. Paper cup in hand, he rummages through the reduced bread bin for croissants.

One evening Charles and his wife, Antonia, take the bus to a cello recital at the Wigmore Hall, thrilled by their Freedom Passes. Declan sees Charles on the top deck and says 'All right?' With no idea who this strange redhead is, Charles averts his eyes, and Antonia grips her bag. Declan writes a ballad about the encounter, with the refrain: 'No smiles now, Mr Waitrose. And you're tight, so you are, like cornrows.' His best yet, he thinks.

LIZARD ONESIE

Miranda, 27, is writing her PhD. The working title is *Gendered Discourse Under Fire: Meta-Marxist Tropes and Applied Linguistics*. It's not flowing. She has already had two deadline extensions, and thinks she may have undiagnosed ME. Her parents are concerned: will their daughter ever leave Oxford and brave the real world?

Miranda wears her lizard onesie whenever she has writer's block (most days). It's awesome. She even wears it to the Bodleian Library, hood up, enjoying what she presumes are admiring glances at her anarchic attitude. The handsome historian to her right is definitely checking her out. She's not sure she should feel gratified, though, and contemplates a chapter on 'female ambivalence towards the male gaze'.

One balmy evening, Miranda is drinking Becks in the Turf, playing Jenga with her friend Marcus. She has swapped the onesie for boot-cut jeans and a wrapover top from Joy. The historian from the Bod appears, and asks Marcus for a light. Miranda says hi, but he doesn't recognise her, so she explains, with modest pride, that she's usually to be seen in a lizard onesie. He looks surprised, but doesn't mention he always thought the lizard in the library was a man.

PHILIPPE STARCK LOUIS GHOST CHAIR

Mandy Ray, 56, was quite a successful model in the 1980s, but now she is always referred to as 'former wife of' her rock star ex. A decade after the divorce she's finally selling their home in the Cotswolds, and with it half the furniture. She wanders round the house, putting stickers on things to auction, remembering her marriage. The décor – lots of leopard print, Far Eastern antiques and a couple of Tracey Emins – is unchanged since 2002. The 12 Philippe Starck Louis Ghost Chairs in the dining room must go. She has a flashback to her ex snorting cocaine off a Ghost chair, before jumping on it and performing one of his legendary guitar solos, naked, to their guests.

At the auction there are some grubby people who must be fans, and two neighbours she recognises from the Daylesford shop (prying, no doubt). The Ghost chairs go for well below the guide price, and she wants to shout: 'They're designer! And Ozzy and Jagger sat on them!' but is too proud. Next week, Mandy sees her chairs in a new tearoom in Cheltenham, full of pensioners on mobility scooters. She knows her ex would find it very funny.

SMEG FRIDGE

Olivia, 32, had to move back home to her parents' in Kentish Town when her flatmate got engaged. It's only temporary. And there are perks, of course, with the power shower and the La Pavoni and nice wine at supper. But up in her old room she keeps stumbling on stuff that makes her heart sink – Paul Nicholls posters and handkerchief tops and dusty lava lamps. Not ideal, now she's newly single.

Olivia goes out most evenings, to avoid kindly questions about her precarious media job. But when she's in, she heads straight for the Smeg fridge, just as she used to between school and *Neighbours*. Having raided the ever-present Parma ham and Sancerre, she gets to work on a cull. Why do her parents have 30 out-of-date condiments? Don't they know smoked mackerel is 'use within two days of opening'? This is the trouble with their huge Smeg – they never throw anything away.

'Ah, the fridge police are back,' says her father cheerfully. 'I'm only trying to stop you getting listeria,' snaps Olivia, hating that she's regressing. She knows they will never change. But her social psychology degree also tells her that organising her parents' fridge makes her feel in control.

HERSCHEL RUCKSACK

Iain, 39, is a fine artist, but his bread-and-butter work is graphic design for big brands. He worries about this damaging his reputation, so he resolves to turn down all commercial jobs until he has finished his current body of work, *Immersive State*. This is a set of muddy canvases, each depicting one of Iain's facial features. A photograph of his nose, from below, is set against khaki green. *Vice* makes a video about it, which starts with Iain cycling to his studio, and a pull focus on his Herschel rucksack as it bumps down Brick Lane. Throughout the video, Iain speaks reverently about the 'materiality of the paint' and each canvas being 'a realm'.

Immersive State is exhibited in a small gallery in Marylebone, by Julian, his art dealer. Iain wanders round the private view wearing his Herschel and a small wool hat, sour wine in hand. He watches how people respond to the work. Nobody buys it. He puts this down to Julian's clientele: monied, but no vision. A month later, severely overdrawn, Iain is forced to design a Mediterranean cow logo for Buttolio, a new 'olive oil spread' that is mostly butter.

GHD HAIR STRAIGHTENERS

Single mum Vicki, 43, sees herself as more of a mate than a mother to Grace, 16. She wants Grace to feel she can talk to her about anything. She's the only mum at school to let her daughter's boyfriend, Callum, sleep over, while Grace vets Vicki's eHarmony matches. They're friends on Facebook, and WhatsApp throughout the day. Vicki loves that she fits into Grace's American Apparel disco pants and wears them more than her daughter, with accompanying selfies.

They even share Vicki's ghd straighteners, which live in the spare room of their home in Reading. Lately, this room has become an unofficial dressing room – littered with communal clothes, beauty products and a huge Swiss ball. When Callum stays over, Grace gets up secretly before he wakes to restraighten her hair and put on make-up. Then she slips back into bed and pretends to be asleep.

One morning, having freshened up and arranged herself on her mauve pillows, she hears Callum tiptoe out of the room. He's gone ages. Later, Vicki tells Grace she walked in on him using their ghds in his boxers. They have a giggle about that. So Vicki doesn't expect Grace to mind when she mentions she was also in underwear.

PANTONE®
Process Yellow C

PANTONE MUG

Ed and Zoe met through mutual friends, when he was at St Andrews and
she at Glasgow School Of Art. They kissed once and then became 'just
mates'. They joke that if neither has married by 40, they'll marry each other.
For Zoe's 33rd birthday, Ed buys her a Pantone mug and writes in the card
'Thought this was very you'. Zoe is nonplussed. It's true she's a designer,
but her preferred mug would be plain white or, at a push, Marimekko. But
Ed, who's a management consultant, can't be expected to understand these
things. Besides, it was sweet of him to try, so she digs out the mug every time
he comes over. He seems to be over a lot lately. She wishes her sisters would
stop mentioning this. They might as well say. 'You're not getting any younger,
why not Ed?' They've even started joking with him about how OCD her flat is.

Ed is gratified to see the mug has been such a hit. He knew it was very
Zoe. So it's a blow when he's helping her reorganise her spare room (he's been
lifting weights and is keen for Zoe to notice) to spot it in a box labelled 'Gifts
– display only'.

OCADO BAG

Anna orders everything for Christmas on Ocado, at 1am, while her husband, Crispin, snores beside her. With all the prosecco, two panettone, 10 poinsettias (on offer) and multiple stocking fillers, her basket totals £402. She tells herself it's for her children, Lucas and Scarlett. She needs to give them a John Lewis ad Christmas to atone for all the missed bedtimes. Anna, 42, works 80-hour weeks in marketing to support Crispin's screenwriting ambitions. They have just moved to an up-and-coming part of Peckham, making for a particularly frazzled December.

On the 23rd, the delivery slot ticks by. Where is Ocado? Anna calls customer services, and is told her shopping has been delivered. Panicked, she checks My Ocado and finds she entered the wrong house number. Has number 34 shamelessly accepted her delivery? Crispin is out 'networking', so she marches over alone. It's the creepy house (the rest of the street, though ex-council, is lovely). A young man answers, reeking of cannabis, and denies all knowledge of Ocado. Inside, she hears a cork pop and manic giggling. She's tempted to barge in and wrestle back her prosecco. Instead, she glares at him, and spends Christmas Eve racing round Lidl, convinced it's karma for missing Scarlett's nativity play.

CLARISONIC CLEANSING BRUSH

Ruby and Caitlin, 19, are childhood friends and beauty vloggers. Twice a week they post cheery make-up tutorials or product reviews from Ruby's bedroom. Usually these involve Caitlin, a trainee beautician, trying out looks on Ruby, as her face suits everything. Ruby, who does most of the chatting, jokes that she looks like a rabbit. It's sort of true, but she looks more like a china doll with big teeth.

They're doing well, but they're hardly in Zoella's league. Then they review the Clarisonic cleansing brush. Soon after, a troll called Girl96 posts a photoshopped video swapping the Clarisonic for a sex toy, so that Ruby appears to be running a buzzing vibrator over her face while making appreciative noises. It gets 10,000 views, and the girls' followers rush to defend Ruby.

After a whole 72 hours in hiding, Ruby posts a no make-up video condemning cyberbullies. Her teary pleas go viral, she appears on daytime TV and becomes a spokesperson for several anti-bullying campaigns. Two years later, she has earned enough from advertising on her new solo vlog, RubySlippers, to buy a small flat. Nobody ever finds out that the troll was Caitlin.

TOMTOM

Camilla, 47, thinks her TomTom is possessed. It often splutters into life out of nowhere, shouting: 'Turn right, turn right', which would take her into oncoming traffic. Camilla, who left publishing to have babies, has nightmares about TomTom luring her Citroën Picasso off a cliff with the children in the back, and Jane saying sadistically, 'You have reached your destination'. She now refuses to use it, saying it puts her off the road.

Today, her husband Giles is driving them from home in Berkshire to Treberzeath Farm, a holiday let near Padstow, Cornwall. The car is hot and glary and smells of bananas and Boris, their Labrador. The boys, George, Freddy and Charlie, already in Joules board shorts, are fighting over an iPad, and craning round to dispense Percy Pigs is making Camilla carsick. They are late and lost, and Giles keeps swearing and demanding the satnav.

The bickering from the back swells, and as Camilla turns to confiscate the iPad, Giles switches on TomTom. All that comes is a horrible heavy breathing, and the whole family is silenced until Camilla screams 'Turn it off,' and rips the device from the windscreen. Years later Freddy confesses he downloaded the TomTom Darth Vader voice.

MOLESKINE NOTEPAD

Stuart, 30, is a project manager and amateur stand-up comedian. He carries a Moleskine notepad everywhere, to record ideas and observations. It's often the little things that spark the best routines. His latest is a riff on 1990s Saturday-night TV, where he muses that his own Gladiator name would be Badger, and does an impression of Our Graham on *Blind Date*. He's also working on something about the self-service checkouts in Tesco.

Stuart is seeing Siobhan, 24, who he met at an open-mic night in Leeds. She used to beg him to test his jokes on her, but now she frowns whenever he opens his special notepad. He jots down 'Siobhan's notepad face is a bit like her sex face' (even though it isn't), thinking it could be the basis of a new routine.

One morning, he accidentally leaves the notepad at Siobhan's flat. Hours later, Siobhan dumps him by email, admitting she has read his notes and is not impressed. Stuart turns the incident into a new spiel about his shambolic love life, omitting the bit where Siobhan said his trademark Liberty print shirts made him look fat. Bitch.

VICTORIA'S SECRET ADD-2-CUPS BRA

Maddie van Stollen, 13, is getting ready for the Teen Tatler Bystander Ball at Lettie's house in Holland Park, with Ines and Portia. She needs to kiss a boy before she turns 14. She's wearing flowers in her puffy blonde hair and a Victoria's Secret Add-2-Cups gel bra. It's weirdly heavy, like a saddle, but it makes her 30A boobs look a-maz-ing. Lettie's father, Dom, is a little shocked when they pile into his Land Rover Discovery. The tall one looks about 25.

The ball is awesome: they get Jack Wills makeovers and are photographed for *Tatler*'s Bystander page. A boy with hair like Harry Styles approaches Maddie on the dancefloor. They grind pelvises while she finds out he's called Leopold and goes to Stowe. Without warning, there seems to be a warm, slimy strawberry in her mouth and she realises they're kissing. It's like slugs wrestling, she thinks, as Leopold's hands hover near her underwiring. She opens her eyes to find his staring back, so clamps them shut again. As soon as is decent she pulls away, taking a selfie of the two of them to show her friends. But there is bigger news: Ines has been scouted by Storm Models. Suddenly Maddie just wants to go home.

KITCHENAID ARTISAN MIXER

Graham, 40, a stay-at-home dad, has got really into his bakes this past year. At first it was just brownies with his kids, Jack and Amelia, but now he's doing macarons, rosemary focaccia and all sorts. He treated himself to a KitchenAid Mixer with his redundancy payout, like the contestants use on *Bake Off*. Silly really, when a food processor would do the job, but Graham does love his toys. Recently, he started a blog, ThisDadBakes, after the Simnel cake he made for the school fete appeared in the parish magazine. Now he's forever asking his family to test his latest bakes for the blog – not that they're complaining :).

Graham's mother-in-law, Barbara, is concerned. Her poor daughter Kim is working all hours and commuting at the crack of dawn, so her husband can mess around 'proving' dough. He doesn't even keep the house tidy – whenever she pops round the kitchen looks like a bomb's hit it. And as for that silly cake mixer that cost a small fortune…. Besides, Barbara tells friends over her trademark Victoria sponge, she'll be baking Jack and Amelia's birthday cakes and that's final.

BODY-MASS-INDEX SCALES

'Stand still and upright. Measuring your weight and height,' says the machine. This is Jemima's weekly ritual. In a corner of Boots, she strips down to her James Perse vest, then steps, as lightly as possible, onto the digital scales. There follows a moment of exquisite tension before the machine spits out a ticket recording her BMI. She keeps these tickets in a special shoebox.

Jemima, 21, an art student at Chelsea, is half glad she developed IBS. If she hadn't, she wouldn't know about her gluten and dairy intolerance, and the toxins in sugar and meat, and she'd still be eating rubbish. Now she's swapped wheat for pulses, and yoghurt for Co Yo, she knows she is clean inside.

Jemima was diagnosed by Dr Calvin Kelppe MA, a Californian nutritionist recommended by *Vogue*, who she first saw about monthly stomach cramps. Following a special finger-prick test, he gave her a long list of foods to eliminate and a £350 bill. After four months on his diet, embarrassing friends with her increasingly odd restaurant orders, she has daily cramps and her stomach feels like a football. On the plus side, Jemima tells herself, the machine in Boots says she is officially underweight.

SWITCH STICK

Every Thursday, Queenie, 90, goes to Zumba Gold in a chilly church hall in Huddersfield. To keep up, she uses a floral Switch Stick. It makes her feel like Ginger Rogers. Queenie has been a widow for 30 years. She had put meeting someone else out of her mind, but there's something about Ron at Zumba. He reminds her of her husband, the way he doesn't mind making a fool of himself.

After class, Queenie always has a cup of tea and custard cream with Val and Irene. One day, Ron stays too. He compliments Queenie's Switch Stick, and they have a laugh comparing hearing aids. Then he says he must dash to watch his great-grandson play football. Queenie does like that.

Next week Ron stands beside her, and jokes that his heart monitor is going 'like the clappers'. Queenie isn't sure if he means what she thinks he means, but feels quite giddy. So giddy, in fact, that during a fast turn she accidentally bops Ron on the bum with her Switch Stick. They're both in stitches. After the class Ron confiscates the stick, saying she can't be trusted, and offers his elbow instead. Six months later they're married.

HAVAIANAS

Jamie, 24, lives in Southfields but his heart is in Sydney, where he worked in a bar for a year after dropping out of Exeter Uni. While there, he acquired a sleeve tattoo and an Antipodean lilt, and started saying 'Yis' instead of 'Yes', which grates on his father, Richard.

Jamie wears his Havaianas as often as possible, regardless of the weather. They always get an airing on hungover Sundays, when he shuffles round Sainsbury's Local in board shorts and a hoodie from the Exeter snowboarding trip, having stopped to muss up his bedhead in a car window. Walking home, he chugs Innocent smoothie straight from the carton.

Since he has 'people skills', Jamie is working as a street fundraiser for Age UK, while he figures out what he wants to do. Only teenage girls seem to stop for him. Everyone else sidesteps his signature greeting (outstretched arms and cheery 'Heya!') without eye contact. It's sad, man. One morning a female commuter treads hard on his bare toes, Jamie thinks on purpose. He yells, 'Oi, watch it, mate!' after her, but she doesn't stop. Jamie's father tells him it was his own fault for wearing 'those absurd excuses for shoes'.

THE SUNDAY TIMES STYLE MAGAZINE

Sunday Times Style has loomed large in Francesca's life. At 21, she used to smuggle it out of the student union to the library, and study Going Up Going Down instead of *Beowulf*. After university she interned on *Style*'s fashion desk, and was thrilled when her suggestion of 'ostrich egg omelettes' appeared on Going Up. The internship didn't end well, when she hung up on a PR who reported her rudeness to the editor. Francesca was shouted at in front of Mrs Mills and Wardrobe Mistress, a memory that still makes her cringe.

Six years later, working at *Style*, she is given a column about modern objects. She is told to research each object's design history, but by now Francesca has been a journalist long enough to know that fiction is easier than fact – so she writes stories about the objects' owners instead. These have a bias towards north London media types (Francesca has never left Islington).

At 31, she leaves *Style* to have a baby. She starts writing a novel in a grubby library on Holloway Road, since she can't bear to be another freelancer in a café with a MacBook Air. Sometimes she takes *Style* with her, to procrastinate. The fashion desk feels a long way away.

This book would never have been published without my brilliant agent Olivia Guest at Jonathan Clowes, who first suggested collecting the columns into a book and persevered for two years to make it happen. I am also indebted to Martin Gibbs at News UK for taking a chance on a new project, and everyone at Pavilion Books, especially Nicola Newman and Katie Cowan.

I'd further like to thank my editors at *The Sunday Times*, Tiffanie Darke, Jackie Annesley and David Mills, particularly Tiffanie who first gave me the column and allowed me free rein over the objects that appeared in it. I'm also grateful to my colleagues at Style for their input, and the sub-editors, for their patience with my constant edits.

Finally I would like to thank my friends and family for their suggestions and encouragement, particularly my parents and parents in-law, without whose babysitting I couldn't have continued the column during my maternity leave.

A special thank you to my mother and my husband Luke, for their love, enthusiasm and tireless editing.